Daughters *of* Men

Daughters *of* Men

Portraits of African-American Women and Their Fathers

RACHEL VASSEL

Photography by Derek Blanks

Amistad

An Imprint of HarperCollinsPublishers

A continuation of the copyright page appears on pages 171–172.

HarperCollins books may be purchased for educational, business, or sales promotional use. For information please write: Special Markets Department, HarperCollins Publishers, 10 East 53rd Street, New York, NY 10022.

FIRST EDITION

Designed by Betty Lew

Library of Congress Cataloging-in-Publication Data has been applied for.

ISBN: 978-0-06-135035-1
ISBN-10: 0-06-135035-4

07 08 09 10 11 ID/RRD 10 9 8 7 6 5 4 3 2 1

To God, the perfect father for all of us

*To my loving husband, Don, for being a hero to our children
and to me*

*To my mother, Jacqueline Chester; brothers, Shawn and
Scott Chester; "mother-in-love," Celta Kirkland; and extended
family and friends, for believing that my dream was possible
and for supporting me along the way*

Train up a child in the way he should go, and when he is old,
he will not depart from it.

PROVERBS 22:6

Contents

ACKNOWLEDGMENTS

Many thanks to my agent, Jacqueline Hackett, and to my partners in this project, Derek Blanks and Toni Acey. I truly appreciate the consummate professionals that you are and the good friends that you have become.

I'd also like to thank Dawn Davis and Christina Morgan at Amistad for believing in this project and for your expertise and direction.

My sincere gratitude to Dr. Michael Eric Dyson for working this project into your busy schedule and for your thoughtful, heartfelt essay.

Much appreciation to my publicist, Lisa Sorensen of Lisa Sorenson Public Relations, for your immediate enthusiasm and ongoing commitment.

Many blessings to Bishop Wellington Boone, Bishop Garland Hunt, and the Father's House Church family in Atlanta, Georgia, for your constant prayers and support.

Lots of love to my children, Victoria, Chase, and Alexandra, for having patience with me as I worked.

I'd also like to express my sincere appreciation to:

Karen Thomas at Warner Books for your advice and friendship;

Susan Taylor at *Essence* magazine for sharing your publishing contacts;

The Southeastern Writers Association for introducing me to talented instructors such as Wayne Holmes (thanks for your guidance and Christ-like generosity), Catherine Ritch Guess (thanks for your positive feedback), and Deborah Blum (thanks for your ideas);

Carl Bradford III of STUDiob3.net for your design creativity and brotherly love;

Pegui Starosta for your strategic mind and for sharing your "people who know people";

Keri Cody for walking with me though the process;

Crystal Garrett for encouraging the artist in me;

Cynthia Dinkins at the Sheila C. Johnson Foundation for securing three wonderful subjects on my behalf;

Lauren Walker, Vicki Hamilton, Christofer Peterson, Robin Thede, Ian Alexander, Kelly Halligan, and also Tiffany Morrison of Lane Morrison Marketing, Jocelyn R. Coleman of Favor PR, Joyce Coleman of the Coleman Connection, and Ava DuVernay of the DuVernay Agency for sharing your L.A. connections;

The Iota Upsilon Chapter of Alpha Kappa Alpha Sorority, Inc., for your sisterhood;

The Program Development Office and the Black and Hispanic Alumni of Syracuse University (where I was first published) for spreading the word about this project;

And my friends and former colleagues at the Weather Channel for your support.

Finally, a big thank-you to the "daughters of men" for sharing your inspirational father stories, and to the featured dads for your wonderful examples.

God bless you all.

R.V.

AUTHOR'S NOTE

As I worked on this book, many of the people I interacted with were surprised to learn that I was not raised by my father. Following my parents' divorce when I was in elementary school, my two older brothers and I lived with our mother—and rarely saw our dad.

But when my parents were together, I remember loving my father. He had his flaws, but he was hardworking, smart, and funny, and I always felt protected when we were together. People would notice how much we looked alike, with our similar complexions, big smiles, and glasses. Our physical resemblance cemented in my mind the fact that we were forever connected—that I was his daughter. I could feel that he loved me and was proud of me. So when my parents divorced, I was devastated that he was no longer a part of my life.

I've learned that God has a way of fixing things that are broken. In my case, He gave me a terrific mother and the key attributes of a strong father in my brothers, my grandfather, and my husband—men who have consistently loved, encouraged, and supported me. Despite my background, I could totally relate to the women in this book, the daddy's girls who delighted in their fathers. I have always been fascinated by strong fathers, so it has been tremendously inspiring for me to have met so many wonderful fathers in person and through the eyes of their daughters. While collecting their amazing stories, I lived vicariously through these women, and I never tired of hearing about the fathers they love so much.

The most important thing I noticed during this project was that there are many paths to great fatherhood. Each of the fathers profiled in this book had a unique style of parenting, yet they were all successful parents. What they have in common is a strong dedication to their daughters. Upon reflecting on her father's sacrifices, one woman I interviewed said in tears, "Fatherhood is free." I immediately understood what she was trying to convey. She meant that no matter what his financial circumstances may be, any man can be a great father if he puts in the time. Some of the dads in this book had busy careers, so they took their daughters to work. Several took their girls on family trips, while others had deep discussions with their daughters while tinkering under the hood of a car or running errands. Many took

their little girls to school, played sports with them, or made them breakfast. Whatever their style or occupation, these men put their time in, and *that's* what their daughters remember more than anything. That their fathers were present.

Daughters of Men provides an opportunity to commend a sampling of the many black fathers who are actively involved in their children's lives. These men are heroes to all of us because their love, sacrifice, and commitment have benefited our entire community through their wonderful examples and through the heart and determination of their accomplished daughters.

One of the greatest blessings in my life is that I've reconciled with my father. We have managed to develop a very honest relationship as we let go of our imperfect past and work toward a good future. I can't tell you what my father's favorite saying is or share with you a difficult period in my life that he helped me through. I can't even say that we're very close right now. But in five years, who knows? The fact is that there's hope for us. In the meantime, I have in this book the combined wisdom, humor, and love of dozens of tremendous fathers to draw upon, and so do you.

Rachel Vassel
November 2007

I Think I'll Color Him Love

Michael Eric Dyson

Over the last twenty years, there has been a great deal of concern about the crisis of young black males—their alarming rates of incarceration, their poor schooling, their social stigma, and their death by unjust police or at another brother's hand. While such attention to our sons is wholly warranted, black folk haven't dedicated nearly as much energy to the plight of black girls. Our daughters have often suffered silently; too often, their need for social support and communal investment has slid quietly off the racial radar. Great psychic harm is done to black girls when they absorb the message that their lives don't quite count as much as the fate of their brothers or their uncles.

But the opposite is just as true: young black girls who feel the love of their parents are able to overcome even huge obstacles in forging a healthy sense of self. Black daughters who know beyond the shadow of a doubt that their daddy loves and adores them tap a source of confidence that the world can't quench. We have heard the stories of woe and absence; we have borne painful witness a thousand times over to black men who scatter seeds in vulnerable wombs only to abandon them before they are properly nourished. But there are other stories too—tales of faithful devotion to the care and protection of adolescent ladies; narratives of nurture in the midnight hour of diaper changes when mothers are fast asleep; and reports of first dates with Daddy in tow to make sure that baby girl won't be hoodwinked or bamboozled by fast-talking replicas of his younger, irresponsible self.

While good black fathers are far more plentiful than either the media or warped social science would have us believe, their far-reaching effect can't be adequately calculated in journalistic accounts—or in cold statistics or flat analysis. The moral beauty of a black father's determined embrace of his female offspring pays off in startling dividends: she won't feel the need to lay with the first guy who is smooth and seductive; she is less likely to be sidetracked by a nagging lack of confidence that often takes hold of those without strong male support; and she won't permit the adamant naysayer to rain on her personal or professional parade. The advantages don't end there. She'll take far more chances in her choice of work or play;

she'll see beyond the provincial thinking that hampers women in sexist environments; and she'll beam with inner pride in her accomplishments even when insecure peers mock her ambition.

The book you hold in your hand is a portable testimonial to the majestic grip of black father love. In the stories of women whose names appear in lights and those whose lives are lit by the sweet joy of their father's quiet heroism, you'll trace the elegant and unmistakable influence of black men on the daughters they have reared. To be sure, bringing up their daughters was a labor of love; this book is a small gesture of gratitude for the mighty task of shaping the souls of sisters who sail beyond narrow horizons and artificial limits.

When God made fathers, the love of daughters was at the heart of the Divine Imagination. When the father helped to make the daughter—whether by blood or choice—the love of God hovered near. At its best, the relationship between father, daughter, and God is an edifying transaction conceived in heaven and lived on earth. But then, every daughter who knows the love of her father knows this already.

Dr. Michael Eric Dyson is the author of several books, including Debating Race *and* Come Hell or High Water: Hurricane Katrina and the Color of Disaster. *He often champions the issues plaguing the disenfranchised in America via his writings, his nationally syndicated radio talk show,* The Michael Eric Dyson Show, *and his ongoing media appearances. A resident of Philadelphia, Dr. Dyson is the Avalon Foundation Professor in the Humanities at the University of Pennsylvania.*

Daughters *of* Men

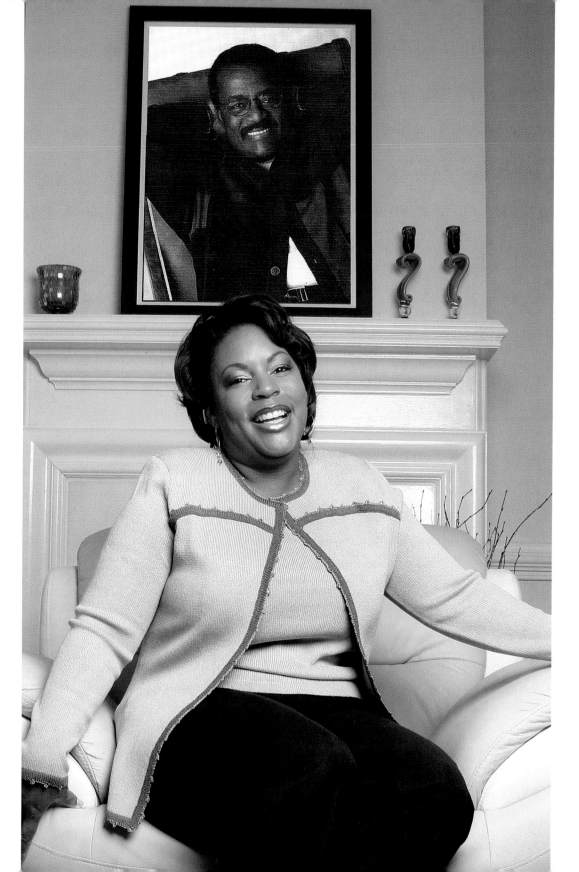

Tiffany Cochran Edwards is an anchor-reporter for WXIA-TV (NBC) in Atlanta, Georgia—the flagship station for the 1996 Summer Olympic Games. Her father, noted defense attorney Johnnie Cochran, died in 2005.

The Ultimate Protector

My first memories of my dad were when I was four or five and we would just hang out together. I'd ride in the backseat of his car, and I'd go with him to run his errands, such as going to the cleaners or getting his shoes shined. It became a father-daughter ritual between the two of us. For me, it was something to look forward to on Saturdays—we'd get up really early and just spend all day together. Then at the end of the day he'd say, "Let's go to Toys-R-Us!"

My dad basically worked seven days a week, so he was always in his office and that was like my little playground. His secretaries would babysit me, and I would just have the run of the place. I knew what he did was very important because when he would meet with clients they were so grateful to him. I'd ask, "Dad, what did you do for them?" He'd then explain what a lawyer does and how he was very dedicated to making sure they got their measure of justice. So I learned early on that being a lawyer, if you're good, you could really make a difference. Not just in your client's life but in the entire community.

He loved being a father. I think he realized that he was so busy career-wise that he needed to make sure that he spent the same amount of time with his children. During his busiest period, the O. J. Simpson trial, I was living in South Carolina. Still, he called me every single day to make sure our lines of communication remained open. He realized that even though he was responsible for making sure he defended Mr. Simpson to the best of his ability, he

still had his own life and he had children who were young enough to need their father. He made that a priority, and I'll never forget that.

He always told me that I was competent and special, and that I was destined for great things. He made sure that I felt smart, attractive, and witty. From my early childhood, he gave me a confidence about myself, that I could go out and conquer the world. I had great self-esteem, and fortunately it stayed with me.

My father was probably the most prepared person for any situation. He always anticipated what was coming next, and he made sure that whatever we did, we were prepared. Do your research, do any homework, and just make sure that you stay on top of your profession. He'd say, "Make sure nobody's more prepared than you and you'll succeed." And that's been one of the best pieces of advice. In my field, broadcast journalism, I have to know what's going on, so it all goes into preparation. He loved being successful, and he expected everyone around him to be successful.

After I graduated from college, I got my first job writing commercials at a television station in Augusta. It wasn't exactly what I wanted to do, but they were going to launch a news department, and my boss said, "Oh, you know you'll be right there and you can slide on in. It would be perfect for you." They held auditions—just me and another girl. She wasn't a journalist, but only an actress who thought she might want to do news. I got to see her audition—she went first and I went after—and I thought I was much better. Just being naive, I thought, *I'm a shoo-in for this.* But I didn't get the job, she got it. I was devastated because I had moved all the way from California and I had a degree. She was only a high school graduate.

I called my dad in tears. I'm not really a crying person, but I was really upset, and I said, "Dad, they hired this woman, she doesn't have a degree, and she doesn't even care about journalism!" He said, "Are you crying?" I said, "Yeah!" "Are you gonna let this knock you down?" he asked. "You're a Cochran!" He told me, "You go in there and you put together a tape and go to the number-one station and get a job there." I was thinking, *Is he crazy?* At the time I wanted him to say, "Oh, baby, are you okay?" Instead, he said, "Stop crying and do something! You've gotta put those tears into action!"

But you know what? I went to work that night, and I put together a tape. And I tell you, I called the number-one station, and they just happened to have an opening. I started anchoring the weekends. I was twenty-one years old, and I was the youngest anchor they'd ever had.

My whole family flew in and watched the TV thinking, *God, can you believe she's on TV?* He told me, "I'm so proud of you. You stuck to your commitment to do this." He also said, "Sometimes in life the worst thing that ever happens to you turns out to be the best thing." He was right!

The thing I miss most about my dad is our conversations. He was such a good listener and problem-solver. You could have just a little tiny issue that you couldn't find a way out of, and if you talked to him about it he'd give such great advice. I think that that's part of being a lawyer, listening to your clients and really seeing what they need. He was able to communicate in a way that everyone could understand.

My dad had two primary mottoes: "keep the faith" and "expect a miracle." I remember during the Simpson trial, all of these negative things were being said about my father, and "keep the faith" helped him to remember that there's a higher power at work. And "expect a miracle" was the second part of that. If you kept the faith, you could expect a miracle. He believed that things really worked the way God wanted them to. You had to believe in God.

When my father was diagnosed with terminal brain cancer, he was given just three months to live. But he lived an additional thirteen months. Until the end, he had such a positive outlook; you couldn't help but be positive with him. It was nothing but God, and he knew that. He was so grateful that he had the opportunity to let everybody know that God worked miracles in his life from the time he was little to the time he knew he was dying.

I remember when he was sick we had a pretty intense conversation. I said, "It's just not fair that you're sick!" He responded, "There's always a lesson. What are you gonna learn from this?" I said, "I have no idea!" I could not imagine life without him. Now I see that the lesson is that he is still so much in me. The day after he died I felt like I was all by myself. But now I really feel as if I can conquer anything, and I know that's him.

I think the most important thing he left with me is his legacy of being a fighter. He never gave up on anything. No matter what, I knew he had my back like no one else. He cared about all people—not just the celebrities but the everyday person. The person who, for whatever reason, ran into some trouble or was victimized. Johnnie Cochran was going to be in your corner, and you knew he'd take care of it. That's what I miss. He was the ultimate protector.

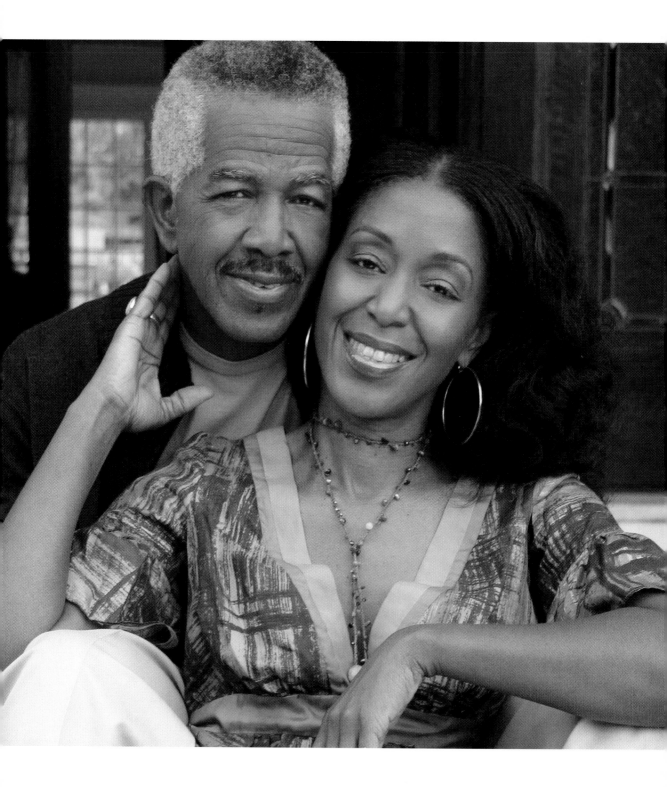

Robi Reed is an Emmy Award–winning casting director and producer. She has cast over fifty films and television programs, including *Antoine Fisher*, *Malcolm X*, *Their Eyes Were Watching God*, *The Tuskegee Airmen*, *Harlem Nights*, and *Mo' Better Blues*. Her father, Arthur Reed, is a retired engineer who resides in Los Angeles.

The Wind Beneath My Wings

My dad is the most responsible, reliable man I know. If you think about a father as the provider, that's my dad. I mean, he's a rock. We never wanted for or worried about anything growing up. All we had to worry about was being a kid because my dad took care of everything.

He denies this, but I think my father wanted a son first. My brother's the baby, and there are three girls, with me being the eldest, so my father did with me things he would have done if I were a boy. I played basketball with my father and his friends. We went camping and fishing—I could bait a hook and cast and catch like anyone else, and I was all of nine years old. He taught me how to play chess too. We spent a lot of time together growing up. I was a "daddy's girl."

My dad was a quiet man back then. Instead of telling me how much he loved me, he would show his love by the things that he would do. I was involved in everything, so if there was anything that required his participation or presence, I remember him being there. My dad was also very protective. When I began working as a teenager, even when I was able to drive myself, he'd want to pick me up from work. I could have girlfriends, no problem, but when I was of age to date, the young men had to pass muster with my dad. In his mind, no one was really good enough for me.

I remember my dad sitting at the table paying bills. He would write on the envelope the amount paid and the check number—everything very detailed. I have a business manager now, but I used to sit with my stack of bills and pay everything in the same meticulous way as a result of watching my dad. Watching him, I learned that taking care of business is what you had to do, what you're supposed to do. Even if you hired someone to do it for you, you made sure it was done correctly.

During my freshman year at Hampton University, I had my first real experience with heartbreak. I was only seventeen when I went away to school, so I was younger than most of the students. I called him crying on the phone, wanting to come home, and I remember my father saying, "What's going on? What do you need?" At the end of our conversation, he got off the phone and made a reservation to get on a plane and come get me. I never forgot that. And even now I know that if I ever need anything he'll be there for me without question. He's the type who will help me first and ask questions later.

I have always been one to take chances in my life and in my career. Some of that may be because I know without a doubt that if I fall my father will pick me up. That's really stayed with me and shaped my personality. If there's some risk involved in one of my pursuits, I'm not afraid of that. My father wanted me to become a business major in college because he saw more security in it. I remember the first week of orientation I thought to myself, *I don't want this. I want to be in theater.* I knew then that I wanted to be a casting director. After discussing it with my parents, my father reluctantly agreed to the change.

After graduating and subsequently working very quickly as a casting agent, my father was very proud. I remember the delight in being able to tell him that I had cast Richard Pryor—whom he loved—in *Harlem Nights* and that he was going to be able to meet him. My father also loves the Lakers, and I remember calling him one day to tell him that I had gotten in touch with Earl Tatum, a young man from Mt. Vernon, New York, where I was born, who played for the Lakers. My father was able to meet Earl, meet all the other players, and go to the Lakers game, which was a thrill for him. That I could have some part in these things was really nice.

I didn't know this for a long time, but my father brags more than my mom. I would realize this when I would meet his friends. They'd tell me, "Arthur's told me everything about you!" They would just start rattling off things about who I was working with and what I had

done. When I'd ask, "Who told you that?" they'd say, "Your father!" I think my success makes my father feel that the sacrifices he made for me were not in vain.

Fathers are often in the background, in the shadows. My father's always been the wind beneath my wings, so to speak. My dad's the quiet storm, that quiet force that has held me up throughout my life. He's a hero because he loved my mother, he loved his children, and he was there for us. We were his priority. It's really simple—he was there and he still is.

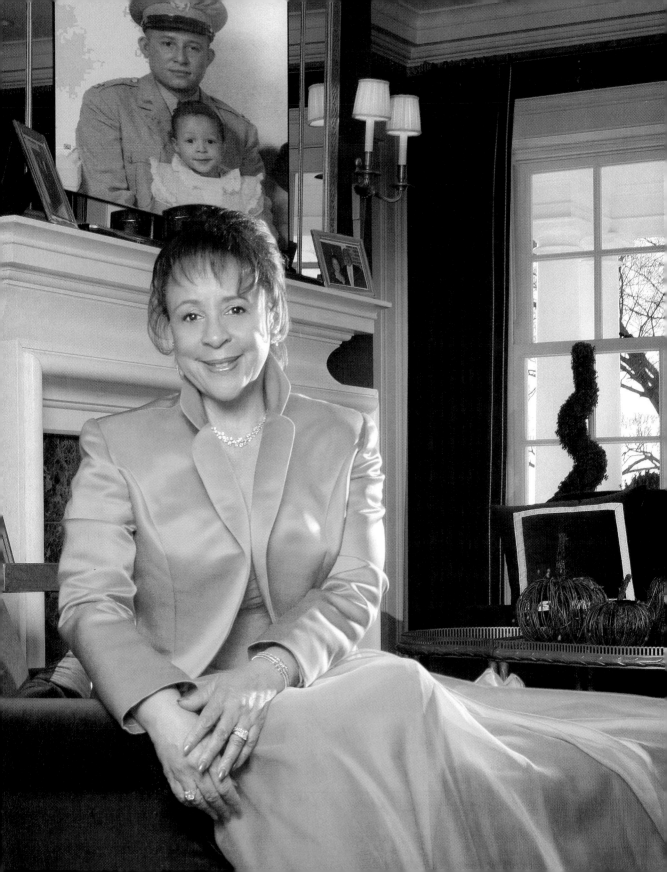

Billionaire Sheila Johnson is the cofounder of Black Entertainment Television (BET) and the CEO of Salamander Hospitality, her hotel and spa business. Her father, Dr. George Peter Crump II, a neurosurgeon, was chief of staff at the Hines VA Hospital in Chicago, Illinois. He died in 2001.

The Perfectionist

My earliest memories of my father involved music. My father was an incredible pianist, and he was always playing in the house—especially after he performed surgeries. It was his way of relaxing. So music was always in our house, and I started playing the piano at five years old and then the violin at nine.

He really wanted me to be a doctor, so my father often took me to the hospital to watch surgeries. I wasn't interested because at the time I wanted to be a violinist. Actually, I performed professionally until 1989. It helped pay the bills while we were trying to get BET started. I was teaching music and performing and also working part-time getting the network operational. Then in 1991, due to the network's momentum, I started working at BET full-time.

My father grew up in Philadelphia. His mother was Italian, and his father was black. They were a professional family, which I believe was rare back then, and lived very comfortably. From what he told me, he always wanted to be a surgeon. He went to Lincoln University for his undergraduate studies and then attended Howard University for medical school. He was brilliant—I mean, absolutely brilliant. Still, he couldn't practice in white hospitals, so he had a really tough time finding work. I just remember the frustration of him getting so many letters of rejection. I do remember one time seeing him cry, which really bothered me. It made

me angry that there was so much injustice in the world. Here was a brilliant man, a brilliant surgeon, and he had a tough time getting a job, even after all those years of education.

Eventually my father practiced medicine as a surgeon with the Veterans Administration. I knew he was doing great work because people talked about his phenomenal capacity to heal patients. I remember there was one patient who he did lose and the family had threatened to sue him. So he actually removed the brain from the deceased's skull, brought it home, and put it on the kitchen table. He began working through the brain and found a tumor. The patient had been misdiagnosed, and it wasn't his fault. Still, he needed to know because he didn't like being wrong. He was just very focused on his work and took a great deal of pride in what he was doing.

He always told my brother and me to be our best and to never take no for an answer. He was really determined and a perfectionist. Whenever I was taking lessons or performing, he was a very tough critic. He would say, "It was good, but it could have been a lot better," or, "The phrasing in the second half of your piece was not correct." To be honest, I always felt as though I could never do anything right. Later in life I realized that if he hadn't set the bar so high, I would have been very mediocre. I had to practice after everybody was in bed, from about twelve midnight to three o'clock in the morning. That's how determined I was. People look around at everything that I've done, and they're like, "How in the world has she accomplished these things?" It's just the way I live my life because that's the way my father taught me.

We really didn't take a lot of vacations. Back then it was a little scary to travel around the country. I still remember segregation. There were certain bathrooms we couldn't use, and we were stopped by the police for no reason at all. They hassled us a little bit. They thought my father was white, so they'd say things like, "What are you doing with that black woman?"—referring to my mother.

My father did not allow us to let any of these examples of racism be a crutch. I think we have too many people, even now, who use racism as a crutch. They decide that they can't accomplish things because racism exists. My father was a clear example of the opposite. Even though he couldn't go into the white hospitals, he still lived a life of significance. He eventually became chief of staff at the Hines VA Hospital in Chicago—the first African-American named chief of staff there. I think that was when I was most proud of him.

My father was proud of everything I did. But he would say that success is doing what makes you happy. I think people put too much priority on the dollar. I know more rich

people who are miserable because they're so focused on making the almighty buck that they've lost their family, they've lost their moral compass, they've lost everything. In the end, the things that are most important are not related to money. It's the happiness, fulfillment, and love that you've brought into your life. There are a lot of people who do not make that a priority. My father saw a lot of my successes before he passed away, but he wasn't really moved by that at all. He was more interested in my happiness. My father was truly a renaissance man.

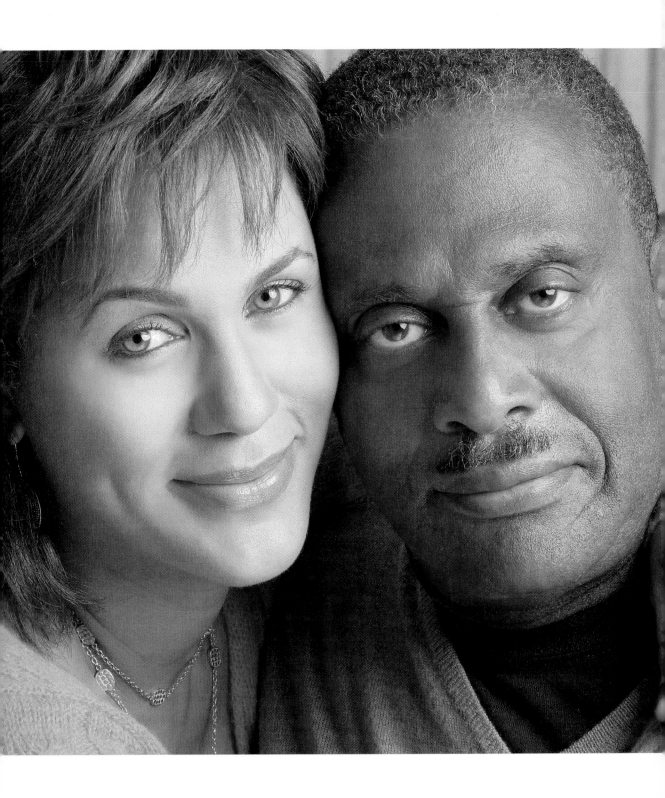

Nicole Ari Kodjoe is an actress best known for her role as Teri on Showtime's *Soul Food* series. She has also starred in several films, including *King's Ransom*, *Brown Sugar*, *Remember the Titans*, and the critically acclaimed HBO film *Dancing in September*. She and her husband, actor Boris Kodjoe, also starred together in the UPN sitcom *Second Time Around*. Her father, Donald Parker, is a dentist who resides in Baltimore, Maryland.

Great from the Beginning

The most remarkable thing about my dad is that he never told me anything that wasn't true and he never broke a promise. If he said he was going to be there after school at 3:30 P.M., he was there. He wasn't early, he wasn't late. It does something to a child when you have no doubts like that. It lays a foundation in your mind and in your heart that everything is gonna be all right. When I think about it, it's not hard to do. My father simply never made promises he couldn't keep.

The other thing I remember is my dad teaching me by example, and he also verbally said this to me, "You have to take care of people." If you go to Baltimore with my dad, you'll see that he respects everybody he meets—from the lady at the bank to the guy at the corner store to the dry cleaner to the cabbie. He treats everybody well. When I was five years old, I was driving somewhere with my mother, and some two-steps-away-from-being-a-wino man yelled to me, "Hey, Nikki!" My mom looked at me like, *Who in the hell!?* I said, "Oh, that's Mr. So-and-So." He knew my dad. My dad spoke to everybody, and he always took me around with him.

My dad is a dentist from East Baltimore, and his father died when he was twelve. He was

the middle child of seven children. There was a lot of change, transition, racism, not to mention poverty that was still going on when he was growing up. It was hard times. Still, my dad speaks so highly of his parents. He has a very strong sense of being cared for, being loved, in the midst of all that. I think that's what he wanted to give his children, no matter what.

When I had my first baby shower, my husband, Boris, and I rented out a roller skating rink and we invited everybody. It was a Saturday, and we had a big crowd. My dad came, of course, and he said that he had never in his life seen so many happy, smiling, healthy, confident black children in one room. This put my father into perspective for me, because I realized then that forty years ago we couldn't vote. We're really just a generation away from really creepy circumstances like segregation. My dad shined shoes when he was little, so those aren't backwoods, history-book memories, because they're just one generation away. You still have those scars on your psyche.

To come out of that and say, I want to go to dental school, when the only way to accomplish that was to drive a cab like my dad did, is huge. To come out of that and say, I want my kids to go to private school when you couldn't, that's priceless. That's something that comes from the inside. There are so many reasons to feel scared and to let everything weigh down on you. But there's a fire of faith in my dad. He still believes that God's hand is in his life. He still believes in miracles. He loves Christmas, and this is somebody who had many Christmases with nothing. That's just something that's inside.

One of the things I always go back to is my dad's resilience. I don't even have to call him. I just think of all of the things he's overcome, and his will encourages me. In Hollywood it's so easy to give up. You're not only told no all the time, but you constantly hear absurd realities about packaging and money and other things that really hurt you as an artist. People say things like, "That's not going to sell," or, "That will never happen," and you have to take that kind of rejection all the time. But the thought of my dad makes me get up. I imagine him saying, "You want to give up? You want to be sad? What's your problem?" It keeps me dreaming, and it makes me want to be productive.

My dad has always taught me never to blame anybody for your stuff. You are responsible for your life. Even when I was a kid and I went through a rebellious phase in school, he'd say, "You know, you can't put on your college application that you were failing because you were angry and trying to make a point." You can't blame anybody. No matter how much they might have done to you or didn't do for you, you still have to live your life. You have to get up

and keep going. He told me this when I was only around twelve years old. It was not a conversation he was having with me on my wedding day!

He has always said, I'm proud of you, and he didn't necessarily mark progress with material accomplishments. He watches my character. He sees how I speak to my husband, he sees how I run my life, he sees how I treat a waitress, he sees how I hold my daughter. It's in those moments that he says, I'm proud of you. He likes the fact that we have a nice life and a nice home and we can provide for ourselves, but he looks at my character development and tells me I'm a good person. He encourages my spiritual growth.

My father is the closest thing to what you're taught God is—unfailing, forgiving, always there for you. I feel so lucky to have known that feeling. It's so easy to be a good dad. You just have to show up when you say you're going to show up, keep your word, and be strong. Let your children know that you're there for them. That doesn't cost anything! You can do it on any economic scale you're on. I know of a professional athlete who flies from wherever he's playing home to take his little girl to school. That's nice because he has a private jet, but he still has to make the effort, even in that economic bracket. Still, if you're without a job, walking your kid to school is free.

My father was the greatest dad in the whole world, and I knew he was great from the beginning. He's so thorough in everything he says and everything he's done. He gave his life to his kids. Everything he did, every tooth he cleaned, every gesture he made was to give his children the life that he wanted them to have.

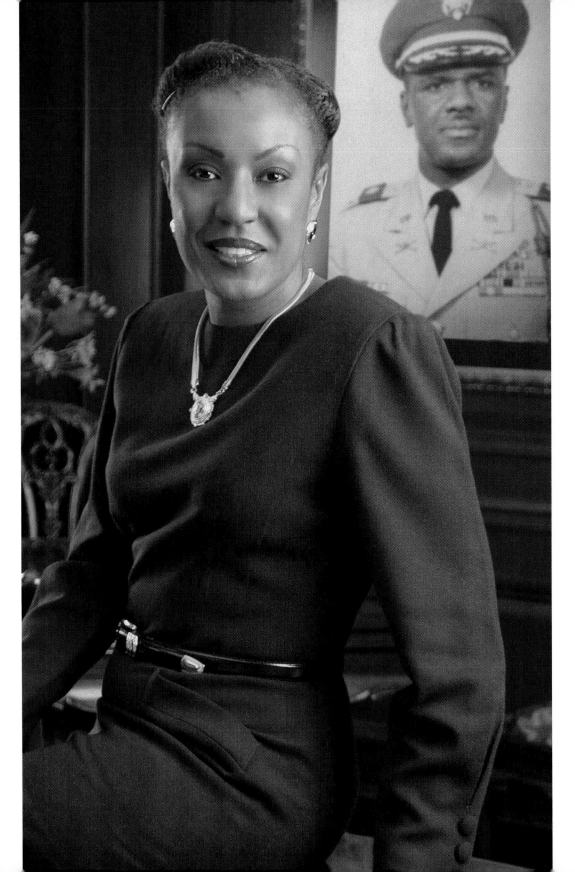

Leah Ward Sears, Esq., is chief justice of the Georgia Supreme Court—the only African-American female chief justice in the United States when she was appointed in 2005. Her father, Colonel Thomas E. Sears, was a retired Army pilot and Presbyterian minister who died in 1989.

Daddy's Princess

My father always called me "Princess." "Princess, do this," or, "No, Princess, we don't do that." I grew up halfway believing I was a princess—in a time when black women weren't the queens or princesses at all. That's what my father was taught. His family was very poor when he was growing up in Norfolk, Virginia, but they all are very confident. They believe they are the best and their family is the best. My grandmother worked in her little store and got them all through college, saving her pennies. They were tough people. It seems as if they got off the boat knowing that they were just displaced kings. They are very, very spiritual. You can hear it in the way they talk: "God has his hands on my shoulder, and that's all I need," they'd say. They believed it, and my father just passed it on to his children.

My father was an Army officer, so wherever he would move, that's where we would go to school. We were the integration generation, so my two brothers and I were always the only blacks in all-white schools. I remember once bringing home all Cs. My father said, "This is not acceptable, this is not what we do." After that, it was all As. It was almost like he'd tell you, "This is not who you are, this is not us. My DNA doesn't create this, so go correct it." Then you'd say, "Oh, sorry." Then you'd correct it. Education was key. His sentiment was that you *will* be well educated. My two brothers are graduates of the U.S. Naval Academy and Stanford Law School, and they have master's degrees.

My parents didn't have a lot of money, but as an officer's family, we could travel on military aircraft when space was available. My father took us all around the world like that. We

went to Vietnam, India, Japan, and Pakistan and even touched down in Hawaii. I was exposed to a lot of other cultures, and I liked the fact that my father wanted us to see the world.

Service to others was important to my father. He thought you should dedicate part of your life to doing things outside of yourself. I of all my siblings was the one most like him, and we could communicate subliminally. I don't know if he taught me so much as it was almost transferred in the genes. That's just how I am. Your job is to help change things, make things better. Don't just sit around complaining—pick yourself up and keep working. In fact, my father's philosophy was "duty to God, duty to country, duty to self through scholarship, good works, dignity, and pride." He just made it up and said this is going to be our family motto. He made us memorize it. He believed we were here to do our duty. Not to make ourselves happy. It's good if you're happy, but duty, responsibility, and commitment are most important. When my brother would complain about married life, he would say, "You're not happy? Well, I'm sorry, make yourself happy! You married that girl and you figure it out. Figure it out!"

We went to church *every* Sunday. When I was growing up, it was something you did unless you were not just sick, but really broke-down sick. Just like going to school or going to work, you got up and went to church. Daddy would knock on your door on Sunday morning. "It is eight-thirty, breakfast will be served at nine, and we will be pulling out of here at nine-forty-five for church. Please be there," he'd say in a deep voice before walking off. You had to be there at breakfast—which, by the way, he would make!

I was only seven or eight, but I was bursting with pride when my dad flew Santa Claus. Actually, he landed him in his helicopter on a parade field so that Santa—really, this old GI dressed up as Santa—could get out and hand out gifts to the kids. He was a black pilot flying Santa! My father looked so handsome and dapper with his wings on his uniform—just beautiful! This sounds stupid, but looking back, it says a lot about him. He was a black man defying the odds, doing what other black men were not allowed to do, or what only a few could do at the time. He looked good and he was confident, and he strolled down with Santa. He did a lot more to make me proud after that. But as a little girl, I thought, *God, this guy's at the top of his game*.

We didn't have a perfect relationship. He had to be the man in charge. This is your typical 1950s guy. As he got older, he loosened up, but particularly in his younger years he was domineering and he knew everything. For example, his name was the only one on the deed

for the house. I told my mother, "You've got to get that changed! You both own the house!" She'd go tell him, and he'd say to me, "Stop upsetting your mother!" He was a good man, but old-fashioned. He wasn't going to take the house from her, but there shouldn't have been an issue about him adding her name to the deed. It belonged to her too, and I would tell him that! It was sort of a happy tension.

I think my father was most proud of me when I called and told him I'd passed the bar. I was the first one in my family to become a lawyer. He simply said, "Okay, Pretty Baby. Good." I mean, *Okay, Pretty Baby?* Tell me! Say something! But my mother told me months after that he couldn't sleep the whole night. She told me that he paced the floor the whole night saying, "My daughter's a lawyer. My daughter's a lawyer. I can't believe it!"

The day I was sworn in as the first African-American female Superior Court judge in Georgia was another proud moment. He held my daughter, who was one or two, saying that he was trying to keep her from acting up, but that wasn't true. He was holding on to her for dear life. When they were swearing me in, it was like a fountain just came down his cheeks. Not a tear, but it was water gushing down his cheeks. I was only thirty-two, very young. Sadly, he died within a year, so he never knew about me becoming a Georgia Supreme Court justice, but I am so glad he got a whiff of what was to come.

He used to tell my mother, "I hope to God that Leah doesn't end up beating her head against a wall." He believed life is just a certain way for women. He was so afraid I would spend my life fighting in vain, but I've cracked the ceiling. I've beaten my head, but it's been worth it. I don't think he would have ever thought that things would be like this for women, and that it would be his daughter, not his sons, who would do this.

What I loved most about my father was that he was a stable man. I know that now after having had experiences with unstable guys who looked better or had more education or who were more suave and all. He meant what he said and he said what he meant. He was always going to be there to back you up. He protected me, my mother, and my brothers and taught us good things. Most importantly, he made us live lives of real deep value.

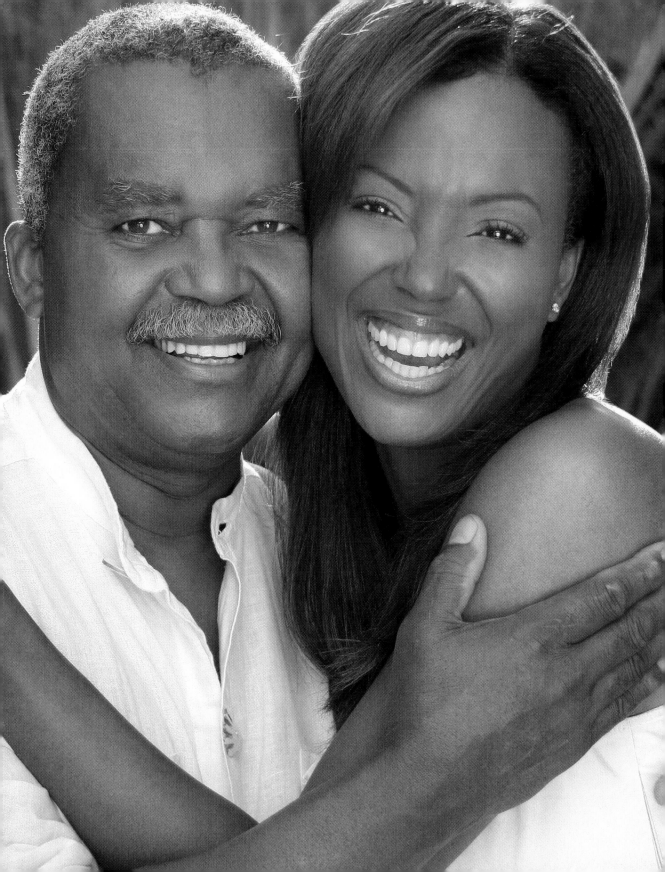

Aisha Tyler is an actress and comedienne who has served as host of E! Entertainment Television's Emmy Award–winning program *Talk Soup*. She has also had roles on several hit television shows, including *CSI*, *24*, *Friends*, and *The Ghost Whisperer*, in addition to several films. Her father, James Tyler, is a butcher who resides in San Francisco, California.

Laughter Is the Best Medicine

My father was the kind of dad who was very loving and affectionate, but he definitely didn't like whining. If you fell and skinned your knee, you got a hug and kiss and that was it. You had to get up and walk it off. I used to always complain and say, "Oh, Dad, you're mean!" Then he would sing this old jazz tune called "Mean to Me" and make me laugh.

When I would leave for school in the morning, my dad used to give me a big speech. It was more of a pep rally really, because he would say, "What are you gonna do today?" I would have to shout, "I'm gonna go out there and conquer the world!" Then he would go, "Whose day is it?" and I would have to shout, "It's my day!" I would do that every morning before I left for school. Even when I was really grouchy and feeling crabby about having to go to school, it would kind of cheer me up and send me tumbling out the door.

My father is hilarious. At dinnertime we would sit at the table and my dad would tell stories. In fact, everyone in my family, in my opinion, is funnier than I am. I'm just the only one who's making a living at it. My dad's the kind of guy who would sweep everything off the kitchen table and get up on it to tell a story. He's one of those dads like when you're a teenager and he comes to a party to pick you up and everyone's like, "Your dad is so awesome!" My dad drove a motorcycle the whole time I was in school, and my friends just always

thought he was the coolest dad ever. He'd pick me up from school, and he'd take me to the video arcade. He'd give us like fifty dollars in quarters—a million dollars when you're twelve—and you could play video games all afternoon. He enjoyed play, and he's the kind of person who's always upbeat. He's not naive or blind, he just believes in being positive. We have this joke in my family that if my father's house was burning down, he'd say, "Let's go get sticks and marshmallows!"

My father grew up in a really awful part of Pittsburgh, and he had almost everything going against him. He's entirely a self-made person and believes in never letting anything get you down. I'm really blessed to have him in my life because when you're young you don't realize what your parents are doing for you. It's not until you get older that you see how much they've shaped you. I'm in such a difficult, competitive business, which can be very emotionally taxing, and I think I've succeeded because I have my father's optimistic, anti-defeatist attitude. He just always keeps pushing.

My parents eventually separated, and it was decided that my little sister, because she was younger, would live with my mom and that I would go with my dad. I think it's really hard to be a single parent, but my dad poured himself into it. The relationship we have is one of intense mutual respect. I realize every day the ways in which my father created the person I am right now, but when I was a teenager I wanted him to be more like other kids' parents. My dad wasn't a coddler. He was very much like, I'm here to feed you and make sure you have a place to sleep, but all the rest of it is up to you. I would have to get up and out every day, and I was solely responsible for my schoolwork. If I wanted a car, I'd have to get a job to pay for it. When you're a teenager and all your friends are getting ferried to and from school and their parents are constantly buying them things, it gets to you. My father never believed in baby-ing me. He's a fierce believer in creating independent people, and he has done that with me.

My father is incredibly intelligent even though he only had an eighth-grade education. He lost his father when he was very young, and he had four sisters, so he dropped out of school to help out. When I was in high school, he wanted to be a crane operator, which requires operating engineer's school. He had to go back to school and learn very advanced algebra and trigonometry. That situation really brought us closer together because I had to help my dad with his homework. It was really very intense because he's a very proud person and I imagine it would be hard for a grown man to go through something like that and not let it get him down. I was so proud on the day he graduated because he really struggled and

he succeeded. I have just this incredibly overwhelming respect for my father. If you tell my father he can't do something, he immediately proves you wrong.

My father also believes that no job is too small to do well. The idea is that no matter what the job is, you take pride in it and do it to the best of your ability. In my profession there are lots people who are driven by image and have the attitude that certain jobs are beneath them. I've always come into this business believing that I should exploit whatever opportunity I'm given and try to do the best work I can do. You never know where that job may take you. I think I've been able to build on my past tiny successes because I've thrown myself into whatever I'm doing with as much passion as if I were the lead in a movie. That's what I got from my dad. The kind of humility that says you can learn from every situation.

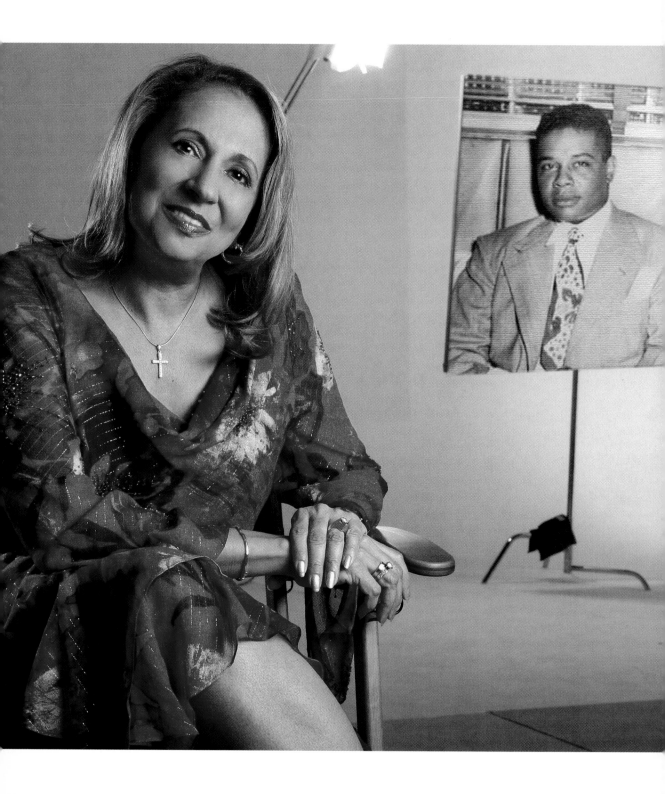

Cathy Hughes is chairperson and founder of Radio One, Inc., the largest radio broadcasting company in the United States targeting African-American and urban listeners. Radio One owns TV One, a lifestyle and entertainment cable television network targeting African-American adults. A former radio personality, she also serves as host of *TV One on One with Cathy Hughes*, a TV One original program in which she interviews influential African-American business leaders, entertainers, and athletes. Her father, William Alfred Woods, was an accountant who died in 1969.

A One-Man Cheering Squad

My mother was a professional musician with the International Sweethearts of Rhythm, so when she'd be on the road performing, it would be just me and my dad. My father was the first black CPA in the state of Nebraska, but when he was in college he waited tables at a place called the Omaha Club, where Marlon Brando, Jane and Peter Fonda, and Johnny Carson were members. I started kindergarten the same year that my father started at Creighton University in Omaha, Nebraska. So my father would bring me to school in the mornings, and then when I got out of school, I would go to the Omaha Club with him and do my homework while he waited tables in the evenings.

At the Omaha Club they nicknamed him "Smiley" because my father was known for always having a pleasant word or expression on his face. My father lived by the saying "Do unto others as you would have them do unto you." This is how I live my life also. I try to be kind to others in hopes that that's how they would treat me. My father used to say, "If you're good to people, it doesn't matter if they say thank you because God will say thank you." He believed that God would pay you back for your goodness to your fellow man.

My father always made me feel so good about myself. He was like a one-man cheering squad for me. I could bring home a D or a C and my mother would chastise me. But my father's philosophy was "Did you do the best you could? Did you really try hard in this class?" If I said yes, he would say, "Then this is a great C." It wasn't like I had disappointed him, because failures weren't failures with him. If you had done your best, that's what was important. That is a lesson that I've taken with me throughout life, and I tell my staff that all the time. If you're giving me your all, even if you fall short of expectations, I'm still going to support you.

When I was older, I became the first employee at my father's accounting firm. He taught me how to save, how to open up accounts, and how to balance checkbooks. Back then they had what they called a short-form tax return, which was an elongated, rectangular card for people who made under a certain amount of money. So I would do short-form tax returns for my father's clients when I was ten years old. The thing that he taught me that has helped me so much in business is my understanding of financial documents. I know exactly what's going on in my business because of the skills my father instilled in me as a child.

My father was a stickler for telling me how to conduct myself. Then I got pregnant at sixteen, and it was as if all his good advice had been for naught. My mother thought it was the end of the world, and she recommended that I get an abortion. But my father was like, "You know, this could very well be the turning point in your life. You don't know who God is going to bless you with. Mary didn't know that her son Jesus's legacy was going to live for over two thousand years. You just need to make the best of the situation." His only request was that I not view it as my life being ruined but rather just as a mistake that I would recover from. And he promised to help me.

My son, who is named after my father, is now the president and CEO of my multi-million-dollar corporation, thank God. I don't know what I would have done if I had listened to my mother instead of my father! I was only seventeen when I left home to be on my own with my son, but I was quite capable of handling my household because my father had prepared me for that.

My father fought against great adversity during his life. Back in those days, it was so controversial for a black man to be handling finances that no one would hire him as an accountant. So for four years after my father became the first black accounting graduate at Creighton University, he was still waiting tables for white people. He also had to work nights

at Skinner Macaroni bagging macaroni until it was such an embarrassment to Creighton that they asked the Internal Revenue Service to hire my father as the first black IRS agent.

He felt very proud about working for the IRS, but it was very racist. Within nine months of his getting the job, they assigned him to outstate Nebraska to do an audit at a white bar where he was pistol-whipped. Back then, IRS agents carried guns, and he walked into this honky-talk, white racist bar to conduct an IRS audit, and the bartender said, "You ain't coming in here auditing sh——," and pulled my daddy's gun out of his holster and pistol-whipped him. He almost died.

The incident was ultimately why my father decided to open up his own accounting firm. Omaha, Nebraska, in those days had one black doctor, one black lawyer, one black taxi cab company, and two or three black restaurants. The black entrepreneurs in town rallied around my father because he was an excellent accountant. Even the IRS had to admit that in the two years he ended up working for them he was their best agent.

My father never once let the disappointments of his life affect his personality or disposition. He was still Smiley—that jovial, happy, just wonderful personality. But after struggling for six or seven years to get a college degree and then being unable to get a job in his chosen discipline, he was stressing out internally—which caused him to have a heart attack and die at forty-five years old. Back then, black men had to contain all of that anger and frustration. I kind of believe that if my daddy had allowed some of that stress to come out instead of keeping it inside, it would not have weakened his heart to the point of causing his young death. We never knew that inside he was crying.

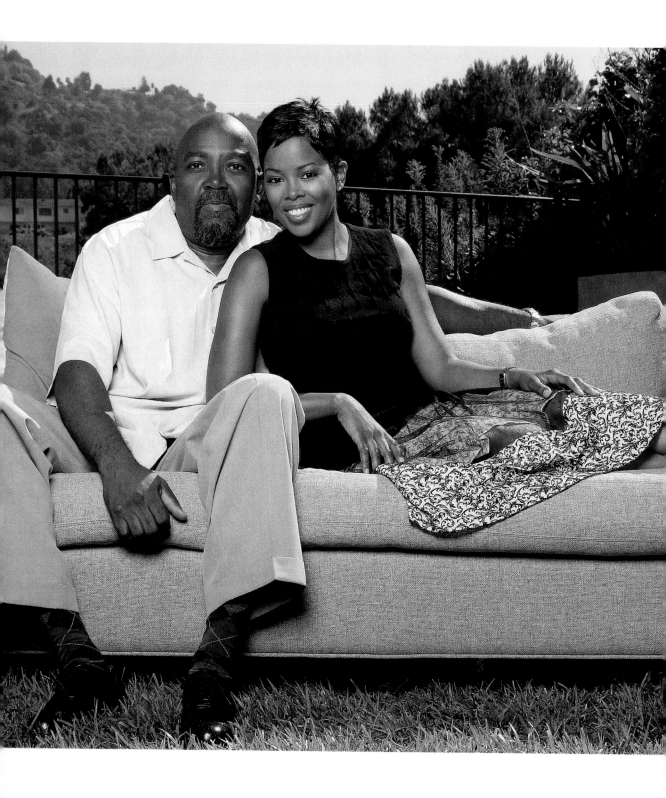

Malinda Williams is an actress best known for her role as Bird on the critically acclaimed series *Soul Food*, which aired on Showtime from 2000 to 2004 and is currently in syndication. She was nominated twice for an NAACP Image Award for Outstanding Actress in a Drama Series in this role and has also appeared in several other television shows and films. Her father, Frederick Williams, is a retired machinist who resides in New Jersey.

Dad's Right-Hand Girl

My first memories of my father are of my two sisters and me getting ready for school in the morning and my dad fixing us hot cereal. I remember WBLS, an R&B station in New York, playing every single morning and my dad making us oatmeal or Cream of Wheat.

One of the things that my father always instilled in us—and to this day it's very, very powerful to me—is that no other person has the same blood coursing through their veins as your sisters. When he said it like that to me, it made sense. He was trying to show us that no matter what happens, you should always have your sisters' back. As a result, my sisters and I are all very close to this day.

Throughout my childhood, my dad was a machinist—he built huge, expansive machines. Dad was constantly working with his hands, and I remember him building lots of things for our home—shelves and desks and things for our room. While my sisters were a little more in tune with my mother growing up, I was with my dad underneath the hood of a car, changing a lightbulb, or working on a project with him in the basement. I would go to him and say, "Hey, Dad, what are you working on?" That was my time with my father, so I developed a lot

of the mechanical skills that my father has. As a result, I have a whole tool chest in my garage, and I can fix anything. Dad showed me how to use many a tool!

My dad was very detail-oriented. I remember sometimes he would open up a book that would give him instructions on how to fix something and I would want to skip the steps. I would say, "Well, Dad, why can't we just go from step A to step D?" He would explain to me why it doesn't work that way. I remember he would pay such attention to each and every little step that at the end of that project you were guaranteed it was going to work.

Now I realize that his attention to detail taught me patience. You can want things to happen in your life, but the time isn't always right for that thing to happen. My father taught me that everything happens in its time, and you have to wait for all the steps to fall into place before that one big thing works for you the way you'd like it to work. His example also taught me that if I put my mind to something, focus and try to develop it correctly, then I can make it happen. My father always made it happen. I don't ever remember a time that my father said, "Well, I don't know what to do now." He always made it work. Sometimes if he came across an obstacle he'd go and buy a book, but he would figure it out. I think that taught me determination.

My father was known in the neighborhood as either "Pops" or "Uncle Fred" because there were a lot of kids in the neighborhood whose fathers weren't around. My father was a surrogate father to some of my friends and even some of our family members. They loved my father because he provided discipline—he treated you the same way he treated his own children. If you couldn't get with that, then you couldn't come to our house. Pretty much everybody had to come to our house because my dad was pretty strict with us girls—he didn't really let us go too far from home. So if our friends wanted to come to our home, they had to abide by Pops' rules. A lot of times children are looking for direction. They're looking for someone to give them boundaries—and my dad definitely had boundaries.

Generally, my father is a very mellow dude. He's cool unless you cross his family—don't mess with his daughters. That was definitely number one. My father had all the boys in check. And we had no problem with that because we knew our dad loved us. He wasn't overprotective to the point where we felt smothered and wanted to rebel. He had just the right amount of giving us a little bit of room but then reining it back in. As a woman, I've come across so many other women who have terrible stories from their childhood—abusive situations where men have done things to them—and my sisters and I never had those incidents in our

lives. My father kept us close, and he was determined that his girls wouldn't experience those things.

I always think, *What would Daddy think?* or, *How is Daddy going to feel?* when I'm making decisions in my life. Sometimes I call to discuss things with him and to see his point of view, because I don't ever want to disappoint my father. I hear my father's voice in pretty much everything I do.

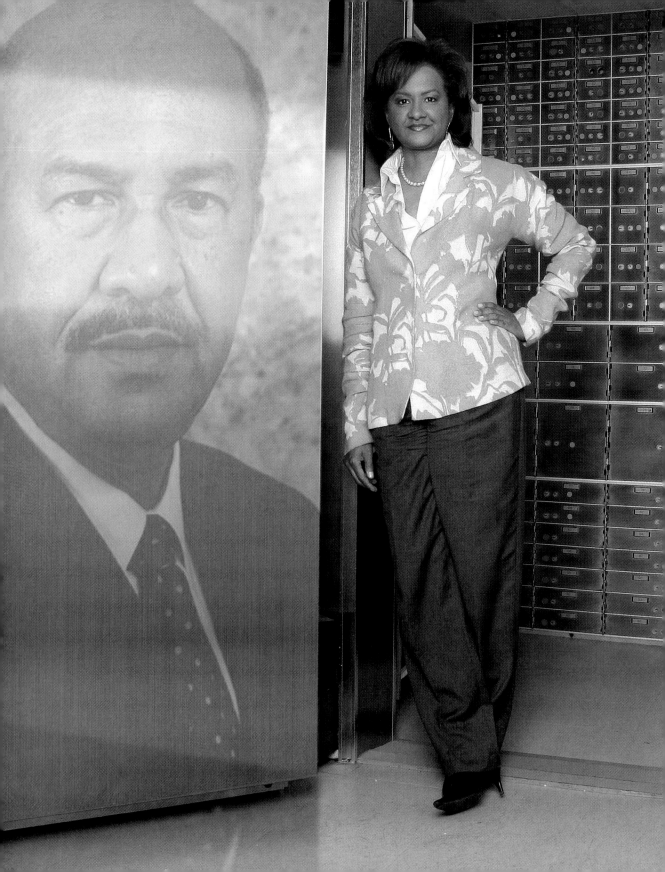

Deborah Wright is chairwoman of Carver Bancorp, Inc., the largest publicly traded African- and Caribbean-American-run bank in the United States, with approximately $735 million in assets. She holds an A.B., JD, and MBA degrees from Harvard University. Her father is a retired minister and college president who resides in Bennettsville, South Carolina.

The Leader

We grew up in the South in a small rural town called Bennettsville, South Carolina. I remember our dad taking two of my siblings and me to school when I was in third grade because that was when Bennettsville desegregated its schools and my dad had offered us up to go to what we called "the white school." My dad's a minister, so we lived right next door to the church that his parents had built, and his mother lived next door. When he was around, he was always intensely around. He traveled often doing speaking engagements, but when he was at home he was very involved in getting us to and from school. My mom was a teacher, and she had to be off to school before us in a different county. Getting us ready was his job during the week.

He was strict. He had this routine on Saturdays that we'd call "the inspection." It was kind of a competition, because you'd win a dime or quarter if you had the best report card. We were always scrambling around on Saturdays so we could get our room in tip-top shape so we could get an extra tip on our allowance—he used to call it a "tip." My grandfather on my mother's side worked for the Boy Scouts of America for his entire career, my mom's mother was a day care worker, and my father's mother was very, very active in the church that she and her husband built. We definitely had folks who were down to earth, but they were

no-nonsense when it came to doing what you were supposed to do, which was getting your homework done and getting the grades that you were supposed to get.

Since we lived in a house that was connected to the church, naturally faith played a fundamental role in our lives as children. With my grandmother living next door and being the matriarch, of not only our family but also the church, there was just constant interplay. For instance, the church used to get the men to bring in trucks to transport these big Thanksgiving dinners that the women of the church would cook for the sick and shut-in. We kids loved to be a part of that.

With my father being the leader of the church, I felt a little of the spotlight because we always had to be on our best behavior. We had to sit right up in the front pew. It was impressive to watch him standing up in the pulpit with everybody looking at him directing the service. He was a really great speaker, too. I used to see him up the night before with his light on preparing for the next day. He had this mimeograph machine, and he would let us put the program together for Sunday services. It would be a lot of fun for us, because he would run them off, and there'd be some drying time, and then we would get to fold them. It sort of told me that you have to work for your glory, that it's not all glamour. It was obvious to me that my dad was a special person, and it was hard not to see that from the front pew.

People would always treat my father with respect. He has certain mannerisms, and he was known to be very well tailored, but not in a flashy way. He was extremely well spoken, down-to-earth, very polite, and he'd always walk around saying, "Wonderful, wonderful, wonderful." Everyone would think, *What is he talking about? What is so wonderful?* We all laugh about it, because it didn't come off as him pretending that things were wonderful, it's just that he was usually in good cheer.

My dad is an intellectual. We had less conversation about the latest rock star and more along the lines of life goals, books, and principles. That part of him is more on the serious side. He also has a pretty good sense of humor. My dad loved a comedian called Red Skeleton. We'd watch his television show together every week. Red had this little hop—he would hop up in the air and get his feet twisted—and my dad would do that all the time to make us laugh.

I had a special bond with my father not only because I was the first child, but because I was born premature and wasn't expected to live. I was born weighing less than three pounds in 1958, so I said in a speech recently, "Being born less than three pounds in a town that still

required you to go in the back door of the hospital if you were black was not an auspicious beginning." Even in that town, which was very segregated and kind of your classic small town in the middle of nowhere, our family had such a great reputation that it really crossed over a lot of relationships. One of the aftermaths of being born early and small and scrawny was that I had some illnesses, including asthma. The main doctor in our town used to meet my parents at the side door after dark to make sure that I got what I needed. This treatment was based not just on my dad's reputation but also on his parents', who literally built a church during the Great Depression.

My grandparents on my dad's side put five kids through college, and on my mom's side there were two kids with college degrees. They were just focused on getting their kids through college so that they could feel comfortable that their kids were going to make it. I have three siblings—my family had three girls and one boy. My brother went to Morehouse, and my two sisters went to Spelman.

I got into Harvard, Spelman, and some places in Texas as well, where we were living at the time. My father was really not in favor of it. He spoke of the family tradition at Spelman as a reason not to attend Harvard. I realized that my father's issues with Harvard were based upon my protection and safety. But he eventually came around. He was like any parent letting his first child go and wanting to hold on to her as long as he could.

In my first job out of business school, I hit a very early wall three years into it. I was making good money, and it was a prestigious job, but I was feeling beat up and like a complete failure. My father, along with the rest of my family, felt that investment banking had no redemptive value to begin with—his sentiment was "You're not helping anybody, and you may be ripping off a few!" When he saw that I was miserable, he said, "Who are you doing it for? Because it's certainly not for us!" He didn't care about the money or the prestige—to him, the only thing that mattered was that I was happy. It really freed me to move on. And it's certainly how I ended up on the path to Carver Bank.

Knowing that my father loved me and believed in me, I could face whatever decisions I needed to make. I had gone away to Harvard and had success in the financial world, but Bennettsville is who I am on the inside—I've come full circle.

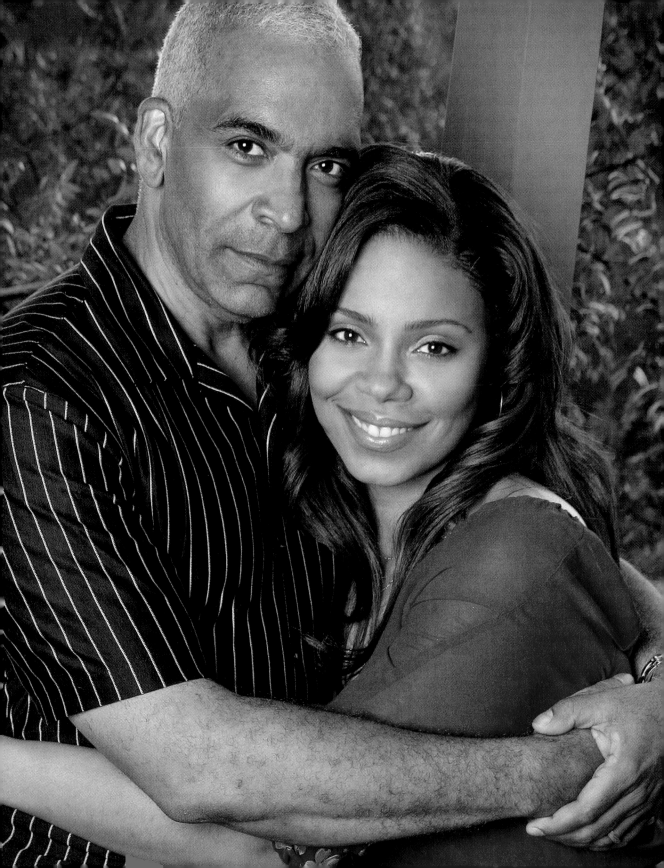

Sanaa Lathan is an actress who has starred in movies such as *Love and Basketball*, *The Best Man*, and *Something New*. She received a Tony Award nomination for her performance in the 2004 Broadway revival of *A Raisin in the Sun* and will reprise her role for the television version of the play being produced by Sean "Diddy" Combs. Her father, Stan Lathan, has directed numerous television and film projects, including episodes of *Russell Simmons Presents Def Poetry*, *Moesha*, *The Steve Harvey Show*, and *Martin*. He lives in Los Angeles.

A "Reel" Pioneer

When I was a little girl, I just worshiped my father. His life seemed so special because he was a successful Hollywood director, and I got to go on set and meet many of the celebrities with whom he worked. One of my earliest memories is of him doing magic tricks for me, like the chocolate-coin-in-the-ear trick. I was really young then, and it was just like, "My dad can do magic!" My mother was into health food, and I didn't get to have lots of sweets, so it was always a treat for me to get those chocolate coins from my dad.

My father constantly let me know how much he loved me. He would write letters to me as a child when we couldn't see each other, because he was always so busy working. He told me I was beautiful and that I was smart. Little things like that, the kind of things that really affect you later on. I consider myself pretty confident, but your parents are a big part of that. So those little encouragements are not so little in the long run.

When I was at Berkeley, I was in a group called the Black Theater Workshop, and when it was time to graduate I decided to pursue acting. I was accepted into Yale Drama School, which kind of legitimized my passion for acting in a weird way, because my dad was very worried. When I told him I wanted to be an actress, he literally said, "Why, Sanaa? Why are you going to do that to yourself?" He knew that most of the time being a successful actor has nothing to do with talent. And he also knew how hard it is for actors to work, let alone black female actresses. He didn't want me to go through that. But my mother was a dancer and an actress on Broadway, and I was always backstage with her or on set with my dad. So between the two of them entertainment was all I ever knew. It was normal to me. Once I got into Yale, he realized I had talent and he was very supportive. He came to see me in plays all the time, and now he's my biggest fan.

When I finished school and started working, there'd be times when I'd literally come home from auditions crying. In those moments it was great to have a parent who has been in the business so long. He would always say to me, and he still does, "Don't sweat any one job, because it's about a career. Just do your best work all the time, and it will work out." And I've learned that that's all you can do. He's also said, "The only power you have in this business is the power to say no." A lot of people think you have to accept everything that comes your way, and you don't. One of the things he made me realize early on is that sometimes it's good to pass on a project. If you're not into it, pass. Have the faith that something else is going to come along.

My father was one of the first black television directors in the country. At the end of the civil rights era, he took advantage of opportunities and developed a career. He's had a lot of success very early on, and he's a real pioneer in terms of black people in this industry. Now that I'm in the business, it's amazing how literally everywhere I go to work—on every production, from actors to cinematographers to producers—everybody has worked with my father. And people love him. I think I have about ten actor friends who are well known who secured their first job from my dad. He's opened doors for so many people.

I'm proud that he's doing things in his career now that he's really passionate about. For example, he was so excited about creating *Def Poetry Jam*, which won a Tony and a Peabody award. It's bringing poetry back to the American consciousness in a unique way. I saw him

light up like I hadn't in years in terms of putting something out there that he really believes is important for the public to experience. He's in a good place.

My father has given so much to so many people. He has opened doors and has created so much work for African-Americans in Hollywood, and he's been such a wonderful father to all his kids. Most important, he has gone through some personal struggles and triumphed over them, which is a wonderful example to my family.

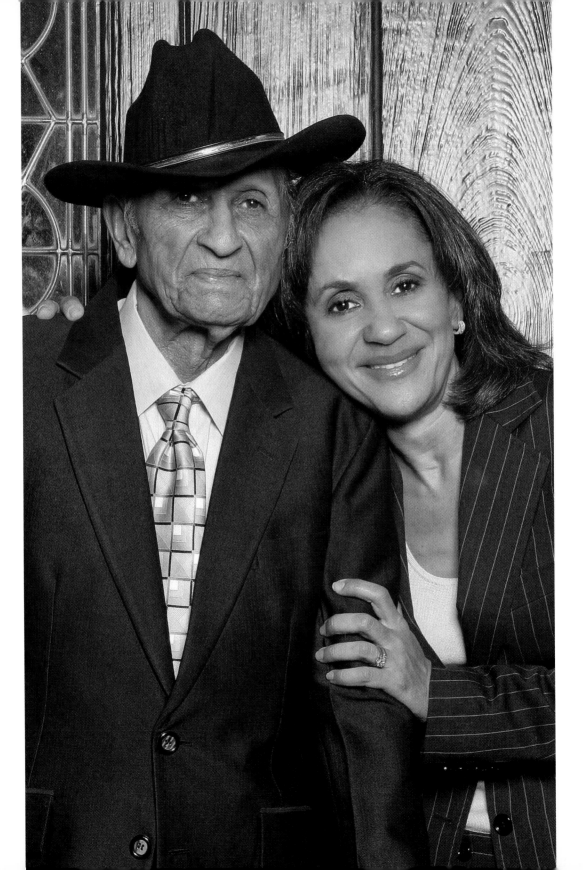

Glenda Goodly McNeal is senior vice president of Retail and Emerging Industries at American Express. Her father, Willis Goodly Sr., is a farmer who resides in Eunice, Louisiana.

Unwavering Faith

My father was a farmer in a small Louisiana town. When I was little, he would come home on the tractor, and sometimes I'd meet him and we'd go for a ride at the end of his long day. He worked from sunup to sundown and was the father of eight kids, so the fun things we did were kind of limited. Still, on Sundays after church we'd go horseback riding together.

My father was the oldest boy, the second child of a family of fourteen kids. As the oldest boy, he began to work in the fields at a young age, helping to support their growing family. As a result, his education was limited. What he talked about most was the value of education and making sure that we had one—even though he didn't have one—and that we did everything we could to excel. In his mind, an education was one thing that could never be taken away from you.

When I was growing up, my father was strict and very firm. He was a true disciplinarian. He was a small man, but he had a big voice. He always meant business—when he said something, you responded. The kinds of things he said were usually corrective, and so he had a different way of showing his love. I think he understood that when you have a big family, order is important. With the limited resources he had raising seven girls and a boy in the South during the 1940s, '50s, and '60s, he knew he had to keep his family under control. He was all about order and protection.

Since there was only one boy in our family and my father had a lot to do, we girls had to work. My father had a lot of land, and we didn't have a riding mower, so we had to cut the grass. We also did the laundry, picked the eggs, cleaned the fish—whatever needed to be done, we were the ones who did it. What was great about that was I grew up believing that I could do anything anybody else could. My father encouraged that, and a sense of that still resides in me. He also showed us that family was extremely important and supporting one another was what made it all work. You couldn't do everything alone, but if you did it all together there was strength in numbers.

Things are so different today. We had homework, we had to do the dishes, and we had to get ready for the next day. I can remember at ten years old I was learning how to iron, and at twelve years old I ironed all my own clothes. Now we're hiring people to do it! We did our chores and didn't question or complain, and our parents sat down after dinner. Today the kids sit down and the parents are still cleaning up the kitchen! We often rationalize with our kids, and we try to explain why we've said no. Back then, when our parents said no, it was no! I wonder if we are doing more harm than good by the significant amount of giving that we do. I find there's so much value in knowing what it is to want, and I don't know if our kids do.

I think about where I am today versus my beginnings. It was kind of hard to imagine when I was growing up that success could look like this. I think my father gave me a very solid foundation around work ethic, around respect, around being a good person and always looking to do the right thing. Today, as I think about the business decisions that I have to make, I don't think about what it means for me. I think about the good that can come out of it. I think that's a different perspective than many people have in the workplace today.

My father's favorite Bible scripture is Psalm 23, which begins with "The Lord is my shepherd, I shall not want." What's interesting is that my father didn't read well, but he memorized Psalm 23. Every night before he went to bed he did two things. He opened up the Bible to Psalm 23 and he "read" it. Then he went to his room, got on his knees, and he prayed out loud for the entire house to hear. I enjoyed hearing him pray because it allowed me to see what he prayed about and the faith he had. One of his favorite sayings was "The Lord will make a way." He had a tremendous amount of faith, and he passed that along to me.

I'm a two-time cancer survivor, so what my father taught me about faith resonates with me every day. When I received my first diagnosis, people said to me, "You're so calm! Are you scared?" Of course I was scared. I was the mother of two young children, and I wanted to be

around to see them grow up. But at the same time I had a sense of calm because I was grounded in my faith. When I was told I had cancer the second time, people said, "Aren't you devastated?" I was disappointed, yes, but there was no way I could control what was going to happen. Freaking out about it was not going to help any. Again, I had to focus on my faith, and I got through it. Strong faith is one of the biggest gifts that my father gave me.

I think success for my father was meeting the demands of daily life. He was really about living and providing—living in order to provide for his family. That's what his world was. He wanted his children to be good, he wanted us to do the right thing, he wanted us to have, as he said, a better life than he had—and he was able to give all of that to his kids. People say that as parents you have to be selfish sometimes about having time for yourself. My father didn't think that way. He did what he needed to do for his family. As I look back, that was a major sacrifice when you have as many children as my father had. He raised eight kids who are good people and all successful in their own right. I would only hope that I could measure up as I think about my own children.

My father achieved so much with so little. He survived in spite of his own limitations as well as the challenges that life put in front of him. Being a farmer back then, you were share-cropping at best, but he never let you see him sweat. He had a job to do, which was to provide for his family, and he was focused on that. I also think about the concept of illiteracy as it relates to my father. It's a very dark world, and my father has achieved in spite of that—which says a whole lot about who he is. He has a tremendous amount of pride, an unbelievable work ethic, and an unwavering faith. Those are the things that define him.

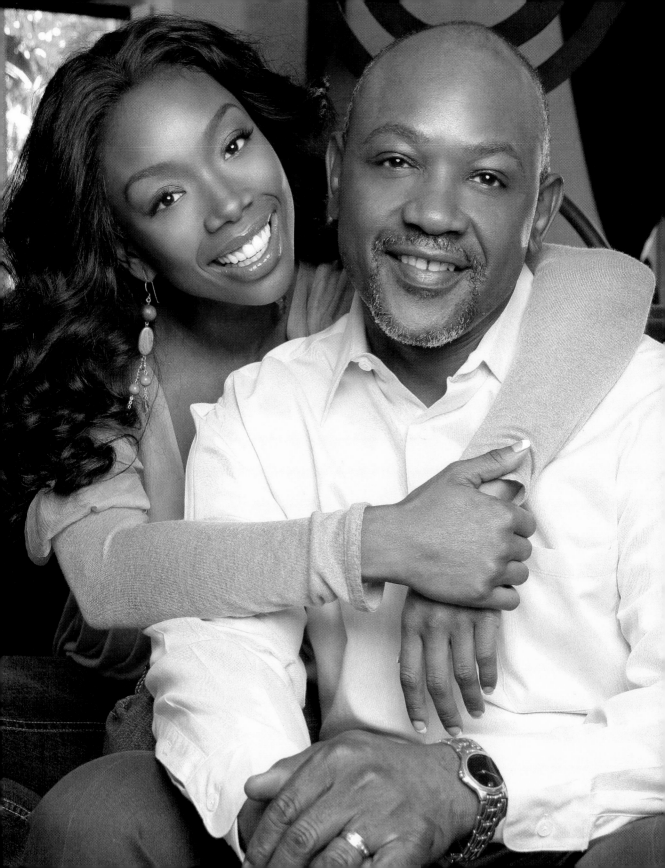

Brandy Norwood is a Grammy Award—winning recording artist and actress. She has released five studio albums since her debut in 1994. As an actress, she is best known for her role as Moesha on the television sitcom of the same name. She has also starred in the television movies *Double Platinum* with Diana Ross and *Cinderella* with Whitney Houston, as well as the popular horror sequel *I Still Know What You Did Last Summer*. Additionally, Brandy was cast as a judge on the first season of NBC's *America's Got Talent*. Her father, Willie Norwood, is a vocal coach and gospel singer who resides in Los Angeles.

Unconditional Love

My father was the first person to introduce me to music. He was choir director at our church, and he sang every Sunday. Every time we would go to choir rehearsal or to church, we would sing together on the way. The three of us—my dad, my brother, and I—would just harmonize and make up our own melodies and sing church songs. He was always singing around us, so that's what we would do. That was our connection and that was our life.

I grew up loving my father and admiring him because he's such a special person. I just remember my dad always singing "This little light of mine, I'm gonna let it shine," which became our theme. Pops is pretty positive. He would always bring a smile to everybody's face. People always say to me, "How's your dad? That man is the sweetest man in the world!" He was a Bible study teacher, so he was pretty much involved in all of the teenagers' and young

kids' lives at our church. All the kids loved him because he shared his passion for music with them. He had choir rehearsals on Saturdays when kids would usually be out in the streets.

When I watched my father perform back then, I couldn't understand how he could be so boundless and how he wasn't embarrassed to really express himself. His passion and showmanship was tremendous. I wasn't able to do that when I was on stage because I was so nervous all the time, so I always looked to him for that confidence. I felt that if I could have the confidence that my father had, I could really make something of my talent. My dad is a free spirit. When he's performing, he's just being himself, and I've learned so much from watching him.

My father has given me lots of good advice over the years. Right before I came out with my first album, he told me to always "stay low and keep moving." I didn't understand what that meant at the time, but now I understand that it means to stay humble. It means that your gifts can lead you to wealth and fame, but it's about being appreciative of what you have. My dad and I have wonderful discussions. I remember a recent conversation I had with him about staying true to yourself and just being honest with yourself at all times. Now I really question everything I do, every decision that I have to make. I ask myself, "Does this represent the highest version of who I am?" That's all because of my father's wisdom.

What I love about my dad is that he was always very open with us about his life and the things that he's experienced. He never hid the fact that he went through his challenges and made mistakes. My father allows me to go through my situations without interfering—but I know he is watching and always there to give me advice. Pops has never really held me back from experiences. I appreciate him for that. He always taught me not to judge myself. He believes that whatever you're supposed to learn, life will teach you that. I've always had open opinions, and I always could ask why and get an explanation. So I believe I'm doing well in life because I had a good upbringing. He made sure that we knew right from wrong, and that we knew what morals and values and standards were.

My father's advice about men is that you can't change anyone and that you should be with somebody who is going to love you unconditionally. What's so interesting is that over the years I didn't choose guys like my dad. I'm twenty-eight years old now, and I've made so many mistakes, but I've learned from them. Now I'm looking for my Pops. Rather, I'm waiting for a guy like my Pops to find me. Someone who is humble and allows me to be myself.

My dad always accepted me for who I am. He never looked at me differently than what I was—his daughter—and he loves me no matter what. For me, the best gift is when somebody who's supposed to guide you can guide you in your own decisions—not guide you according to what *they* want you to be. My father treats my mom well, he treats his children well, and he's always been a good example. He's like an angel.

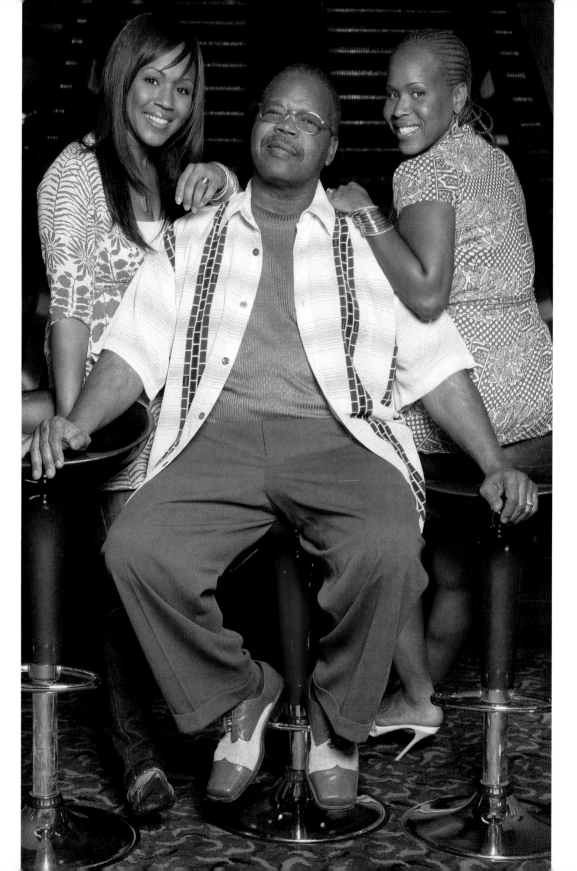

Sisters Erica Campbell and Tina Campbell make up the Grammy Award–winning, platinum-selling gospel group Mary Mary. In addition to their breakout debut album, *Thankful*, they have released gold records *Incredible* and *Mary Mary*, and a Christmas album, *A Mary Mary Christmas*. Their father, Eddie Atkins Jr., is an operating room technician who resides in Los Angeles.

The People's Minister

Erica Campbell

I remember when we were younger, my dad made the most incredible spaghetti, and we would always look forward to it. He was a very methodical cook, so everything from the cutting of the sausage to the way he cooked the meat to the way he would add the pasta to the way he made the sauce was done in his particular way. The spaghetti would be so great, but more than that, it was fun to watch him cook because my dad is such a crack-up.

My dad grew up in California living with his mother and his sister, and they didn't have a lot of money. It was always God first with my grandmother, so my dad grew up going to church. But most of my grandmother's family was not really churchgoing, so he was different from his cousins in that way. Most of them were hustling and killing and gangbanging, but my dad took a different path. He decided to go to the Army and go to school. Then he accepted his call to the ministry and married my mom and started having kids. One thing that I could always respect is that crime was never an option for my dad. There was a different kind of determination he had to make things work.

Our parents divorced twice before finally remarrying a third time. I guess three times is a charm! I know with a lot of men, if it doesn't work out the first time, they'll move on, so I

think my parents' relationship says a lot about him. I think it taught me and my sister so much about love and the ability to stick with it even when it's the hardest thing to do.

For most of our childhood my dad worked at the post office, but preaching was the most important thing in his life. Tina and I always remember my dad's prison ministry, when he'd go to the prisons to preach. If he wasn't in a prison somewhere, he would find the roughest neighborhoods in Los Angeles and just go out and witness. Sometimes he would get a microphone and bring all of us out there with him. We would sing and just share Jesus with people on the street where they were. It didn't matter if they were drinking and smoking or on drugs, we would show them love. I think that had a major impact on me and Tina as Mary Mary, because our music has always been for everybody, not just for church folks.

I remember being in a store about seven years ago, and a guy came up to me and said, "I know you." I thought he was trying to hit on me, so I was going, "No, you don't know me." He insisted, "Yes, I do. You came to the prison with your father. Your father prayed for me, and he kept in touch with me, and when I got out I got a good job, and I'm taking care of my family—and it's all because of your dad." He said, "Tell him I said thanks!" I was so happy. It made me feel great, because sometimes you just see your dad as dad, but to know the impact that he's had on other people has given me a different kind of respect for him. He's faced loads of obstacles, but he has given so much of himself to others. He's always been a strong and loving dad.

Tina Campbell

One time when we were really young, my dad took us all to the Little Folks Shop when he got paid. It was a shop where they had really great kids' clothes, and he bought us all two outfits each, and then he took us to Big Boy's restaurant. I remember thinking, *He's the greatest man ever!* I just thought he was so wonderful for doing that.

My dad was the boss of our house, but he was a lot of fun too. He used to actually let us play tic-tac-toe by rubbing a lot of lotion all over his back and using our fingers to write the Xs and Os. He would hate for me to say this, but sometimes—if we begged him enough—he would let us do his hair. We would put barrettes in it, and then he would get up and do this ridiculous, totally ungirly smile that would make us all laugh. My dad is the most manly man that there is, but he would do it for the laugh, and then he would make us take the barrettes out immediately! On his day off from work, he would make us these incredible pancakes.

He would put the butter on them in his methodical way, from one side to the other, until the entire pancake was covered in butter. They were the best pancakes in the world.

The fact that, as Christian girls who grew up in church, we have a ministry that is so relevant to the street is a direct effect of my father, who exposed us to a lot. The way my dad dealt with street dudes always stayed with us. He would pray for them in a way that didn't put him above them, but he still stood for godliness. He would interact with them in a way that gave them the desire to be better. He poured that into us. We came out singing straight-up gospel music, but we were not in Christian communities initially. We were in clubs and on hip-hop shows, and it was amazing because we're church girls! It makes sense because we lived in those communities. A lot of people who were not church people were in our family, too.

Dad is definitely strong, and he's full of faith. His favorite scripture is from Psalm 24: "If you faint in the day of adversity, your strength is small," and he has lived it. We were a family of seven girls and two boys, but one of my brothers passed away at an early age because he had a hole in his heart. So there were eight of us left. But my dad, bless his heart, was always taking somebody in. We had nieces and nephews and cousins who lived with us for so long that they became brothers and sisters. We had minimal income, so it takes a lot of faith to believe that God will find a way to make your resources stretch until all of your needs are met. But that's something I saw my dad do.

In 1974 my father was diagnosed with a rare disease called Cushing's syndrome, which affects your adrenal glands and causes you to become easily exhausted. His energy would just be gone from him, and it sometimes affected his memory. It forced him to stop working for some time. One day he decided that he was tired of lying on his back, and he just got up and started working again. Sometimes it would be hard. Sometimes he would get sick and they'd have to send him home, but he kept fighting because he's always said, "Sick doesn't work for me."

I don't care how awful your situation is, how depressed, or how frustrated you are, you will always find a way to laugh when my dad's around. I know that seems simple, but it is so helpful to laugh in life. He'd always bring the laughter, and I think that's a great quality.

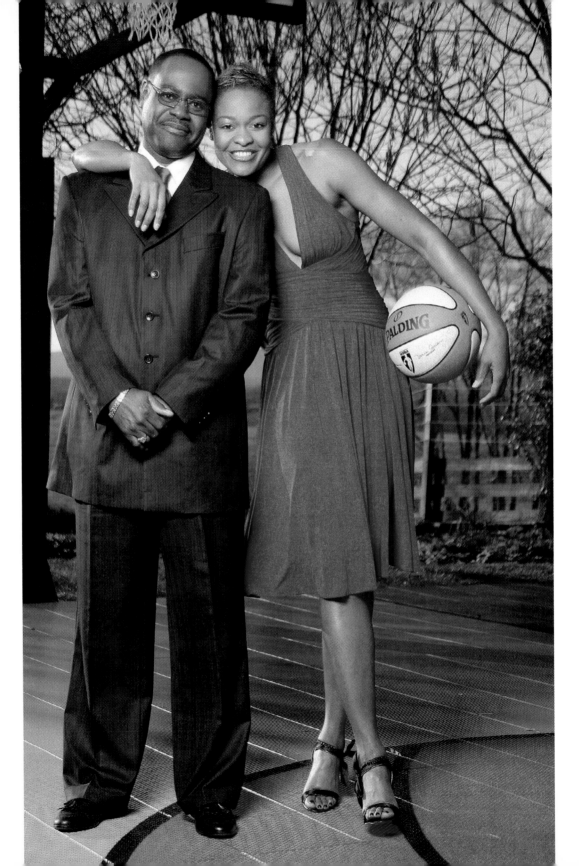

Alana Beard is a guard-forward with the WNBA Washington Mystics. After being a three-time All-American at Duke University, she became the number-two draft pick overall in the 2004 WNBA draft and is a two-time WNBA All-Star. Her father, Leroy Beard Sr., is a truck driver who resides in Frierson, Louisiana.

Exactly Alike

My mother would always give me a choice of whether I wanted to stay inside and help her clean and cook or go outside to help my dad in the yard. I would *always* choose to go outside with my dad. Whether it was cutting the weeds, mowing the lawn, or doing some work on the house, I was out there helping my dad. I would stick with him no matter what.

My father is a truck driver. His job is dangerous because he hauls chemicals, but he's done it for twenty-two or twenty-three years, and it's something that I've always admired about him. As much as my dad stayed on the road during the week, he always made time for us on the weekends. Whether that would be taking us out to eat or taking us to the park to play basketball with our friends, he was there.

My friends admired my dad because many of them didn't have father figures in their lives. They respected him a lot, they looked up to him, and they listened to him. My dad believes in working hard, and he has always instilled the principle of hard work into anyone and everyone around—not just me. His words of wisdom were in the simplest terms, but they made an impact. One thing that he would always tell me was "If you want something done right, you've got to do it yourself." We would just have basic conversations where he would share life lessons like that.

People look at my dad and they say we're spitting images of each other. If you were to ask my mom, she would say that I'm exactly like my dad in just about every way—the way that we think, the way that we walk, the way that we manage our money (my father would give you an earful about saving for rainy days), and the way we manage our time. He has always been very systematic and organized. And that's me.

My father encouraged me by constantly giving me praise when I did something right. Whether I was helping outside in the yard or doing something in school or on the basketball court, he would always, always praise me. And one thing I can say—he definitely instilled his work ethic in me. I never once saw my dad take a break to this day. He works hard because he feels responsible for taking care of his family.

Although my father was the youngest of nine kids, he was the one who his family always depended on. That's another reason why he feels he has to work so much. He also had a father who worked hard for everything, and I can remember him telling us about what his father would do. Without a doubt, my grandfather was his primary role model. My father even turned down a trip to go to Brazil with me with the USA Team because he felt like he had to work. He loves what he does, but he also feels that he has to do it. I sometimes hate that he feels that way, but I also have to thank him for being that way because that's how I am too. I can see how far his hard work has brought him over the years.

I think my father was most proud of me when I was in high school. Even though he didn't like to miss work, I remember he took off to come to one of my games when I was in the tenth grade. From that point on, he never missed a game. That's when I knew that he felt a special sense of happiness in his heart for me.

You can tell the difference between a child with a father in their life and a child without a father. I think for a young woman it's very important, simply because it teaches you how to respect yourself. I'm not saying that those without fathers don't respect themselves, but I think that there's a higher percentage of females with fathers who probably do. They have a toughness about them that a lot of girls without fathers may not have. I never once took that for granted.

With my dad being from Louisiana, race was a huge subject in our household. It's still a huge subject! He would tell us that we've got to work harder than the next person. Even if we're equal in education and experience, he believes that a black person must always work harder. He's dealt with it on his job. I remember the days when he would call and talk with

my mom about it. I think in his twenty-plus years of trucking he's only had one accident—which really wasn't his fault. He's a perfectionist when it comes to his work, but he was never recognized for it. Other people who didn't have as clean a record got all the recognition. Nonetheless, he overcame it, and he worked even harder to get ahead.

I've always just sat back and watched how hard he worked in every aspect of life. Whether it was mowing the lawn or getting up at two o'clock in the morning to go to work, I've always been proud of him and I've always respected him. He is resilient because he has come through everything that has been thrown his way. He's constantly pushing to get better at something, and I love him for that. Also, my father believes in God and has a huge heart. He'll do anything for anyone if they need help, and I think that's very, very special.

ALANA BEARD

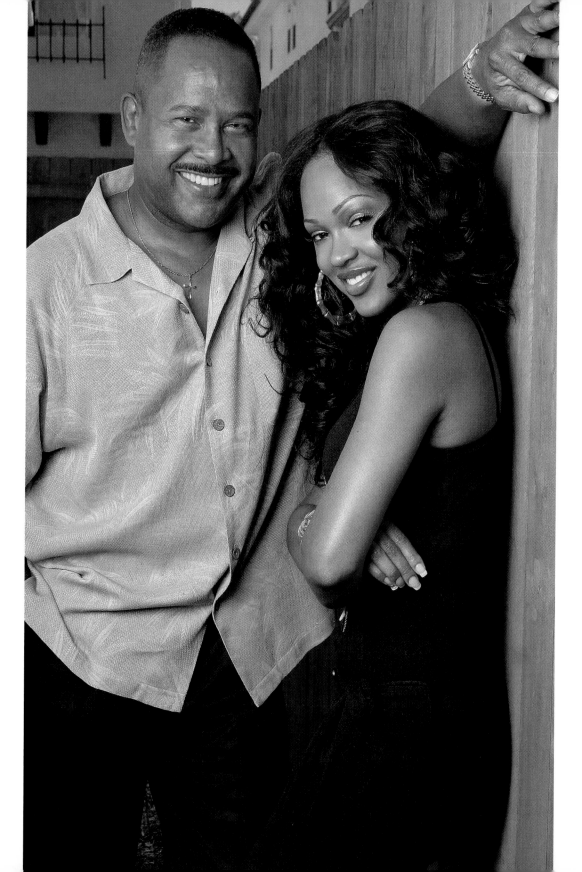

Meagan Good is an actress who has starred in movies such as *Stomp the Yard*, *Biker Boyz*, *Deliver Us from Eva*, *Waist Deep*, and *Eve's Bayou*. Her father, Leondis Good, is a police officer in Los Angeles, California.

Follow Your Heart

My father is a police officer. I remember every day when he'd come home my sister and I would run outside and wait for him because he would pull up on his motorcycle. He had his cop bike, and when he pulled into the driveway we thought it was the coolest thing in the whole world. All the kids in the neighborhood would run to our house and wait with us to watch.

He loves his job. He's all about helping and protecting people and keeping them safe. Now that I'm a little older, I really understand the magnitude of putting yourself in the line of fire on a daily basis to protect people you don't even know. I can't tell you how many times he's been in the hospital. He just gives up so much in order to look out for others. That's incredible to me, because people don't generally do that for other people. They're not usually built that way. My dad believes in what he does and he believes in humanity—that people will be better tomorrow than they are today.

My parents separated when my sister and I were four and six years old, respectively. When parents separate, a lot of kids don't have the opportunity for their fathers to still be around. My dad has made every attempt to remain in our lives and has been there as much as possible. He would always call to talk, and he made himself so available to us. He also taught us how important it is to be close to your family. At the end of the day those are the people who will care for you and understand you the most.

My mom initially exposed me to acting as a hobby. Other kids went to ballet practice or soccer practice, and I went on auditions. It was something to do for fun. Then, during my sixth-grade year, I had an issue with my history teacher at school, who was kind of racist. She was always just letting me have it. Other little girls in the class could wear lip gloss if they wanted, but if I wore it she'd take mine away. She made it very difficult for me to get the grades I needed in order to get a work permit. You see, to act as a child, you need to have a work permit, which requires a C average. And I would ask her to tutor me and help me out, and it just didn't happen, so I was out of acting for a whole year, owing to my grades. I then thought, *This must be what I want to do for the rest of my life because I just miss it so much.* I decided that I would do anything to get my work permit back. I went to summer school and fixed my grades, then came right back at it. I knew at eleven years old that I wanted to act.

A lot of people would have seen the dream I had as a kid as far-fetched. A lot of parents would have encouraged their kid to think or try something different, because "that's not realistic, honey." But my dad was like, "Go for it! Go for what your heart desires." Parents always tell their children, you need a plan B, but mine weren't like that. They felt that if you had a plan B, that was what you would fall back on. So go for plan A with all of your heart and all of your soul.

When I finished high school and I told my dad that I didn't want to go to college, surprisingly, he supported me in my decision. I explained to him that even though I could learn a lot in college about what I wanted to do—acting, directing, producing, and writing—I felt it would be best to learn it from someone who'd been doing it for years. I didn't want to go to college and learn my craft from people who had never been part of an actual movie. My dad said, "Well, I think that you should go, but if you don't, I support your decision." My mom is very creative. She didn't finish college because it wasn't for her. I kind of felt that way too. My dad is not like that, but it's cool that he supported me anyway. He told me to follow my heart.

I asked my father, "Dad, when were you most proud of me?" He said, "Every day of your life." Then I said, "You weren't most proud of me after I got that job that I'd been wanting forever? Or when I made this or that decision?" He just replied, "I'm proud of the little girl you were, I'm proud of the woman you're becoming, and I'm just proud of you." That made me feel like, *Oh, Dad!*

Once he was hit by a car while on duty and ended up in the hospital. When I went to see

him, I didn't know what he was going to say or what he was going to feel, but he was so okay with it. He said, "Everything that we experience is necessary for where we're going in life. This could have happened to someone else. But I'm glad it happened to me rather than someone else." Then he assured me that he was going to be fine and that he was going to get back on the job. Without even knowing it, he inspired me so much at that moment. He made me proud to be his daughter because of his willpower and his heart. My dad has given up so much of himself for the love of other people. As a Christian, that's important to me, because that's what the Bible tells us to do. To love other people as much as you love yourself. And for my father to truly exemplify that and not even know any of the people he does that for? That makes me proud every day.

My dad really encouraged me to follow my dreams. He taught me that if I want something badly enough I could have it. When someone puts that in your head and makes you believe it's a fact, it becomes a fact. I've had the luxury of growing up not thinking of a plan B. Because of my father, I have done nothing but say, *This is going to work—nothing is going to stand in my way. This is what I want, and I'm going to have it.* My dad also taught me to pray and make sure that whatever I want is also what God wants for me. Being steadfast and asking, "Lord, is this what you want me to be doing? Is this how you want me to glorify you?" With all of those elements working together, I feel completely unstoppable.

I love my dad because he found a way to make an impact on his children's lives even though his marriage to my mother didn't work out. He found a way to be a father when he wasn't in the home with us, while at the same time balancing a dangerous and stressful job. You don't find that type of quality every day. I've met some wonderful, beautiful men, and I have been in love three times. Still, I haven't known a man who I think is greater than my dad.

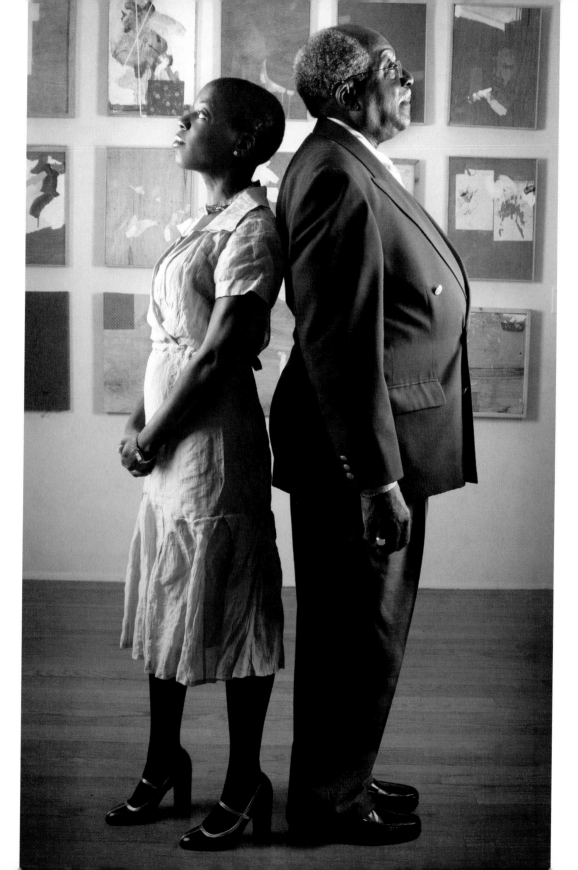

Thelma Golden is director and chief curator at the Studio Museum in Harlem, a leading museum dedicated to African-American art. Her father, Arthur Golden, is a retired insurance broker who resides in Queens, New York.

The Cultivator

My father was an insurance broker, and he ran his own business. He worked a lot of the time, but the time that I did spend with him was really special. I can remember working in his office filing paperwork for my allowance. When he worked on weekends, I would often go along with him to visit his clients, which was how I came to know exactly what he did. It also gave me a sense of my father's work ethic.

My father's clients were small-business owners in the community and nonprofit entities, such as day care centers and churches. Many of them were also immigrants. A lot of their business probably could have been done over the phone, but quite often my father would visit them in person to ensure that they understood what he was doing and to explain things to them. He would work with his clients, helping them to navigate the very complicated systems of insurance and real estate as they were trying to do things for their businesses. I learned that he wasn't just a business owner but an advocate. My father was someone who spoke a lot about using your resources to be of help to others.

I was always interested in the arts, and my father was the first one to take me to see the Dance Theater of Harlem and Alvin Ailey, the first one to take me to see theater. As a child, I saw plays that were completely transformative, like productions from the Negro Ensemble Company. I think about people like Gloria Foster and these amazing actors and actresses I saw perform—all African-American.

In so many ways the fact that I am committed to black culture is not weird because my sense of culture really began with black culture and moved out into seeing other things as I got older. You know, you hear people say, "Well, I didn't know that black people danced modern dance." Well, I'd have to say, I saw Alvin Ailey long before I saw Martha Cunningham or Trisha Brown or Martha Graham's company. I saw Judith Jamison first. That was my vision of dancing.

I was probably in late high school, early college, when I saw George Wolfe's *The Colored Museum*. Again, it was something my father took me to see. We also went to see the range of free offerings in culture around New York City. I saw things like the opera and the orchestra as well. These were all known to me, so the idea that I loved them was encouraged, and it really became clear to me in high school that I would have a career in the arts.

My father never was one to say things, those words of encouragement in a specific directed way. What he did do for me, which was such a gift, was encourage my own ambitions by supporting them. He would say, "Oh, you like to read? Well, here are some other things that you should read." My father encouraged me to read *New York* magazine because it covered art and there were reviews of operas and all these things that I expressed an interest in. He wanted to encourage that level of exposure in me, so I also began to read the *New York Times* when I was nine or ten years old.

He was forty when I was born, so my father was a real grown-up when I was a young child. He didn't necessarily have the capacity for dealing with me as a young child. I feel like in so many ways he skipped over certain things. For example, there was never a point where he was buying me dolls or whatever—instead he told me to read the *New York Times*!

We loved to watch *The Mary Tyler Moore Show* together. In many ways I realized that this had a profound influence on me. The vision of a woman working and being independent was something that he intuitively encouraged because of the fact that he liked that show. There was one particular episode when Mary's boss comes over for dinner and she's serving lamb chops and she doesn't have enough for everyone. Ed Asner's character had taken two lamb chops and that messed her up. I remember my father was watching that, and he told me that you always have to be prepared. I bring that up to him all the time now. I say, "Daddy, do you remember that? How you were just like, 'You see? Mary Tyler Moore, she was not prepared! She didn't have enough lamb chops!'" He found a life lesson for me even in an episode of *Mary Tyler Moore*!

My father's father passed away when he was young, so he was raised in Harlem by his mother and his grandmother. He went to public school in Harlem and then to City College until he went to the Korean War. He served in the Army, and when he came back, he finished his education at Howard University and then did his graduate work at New York University. He was raised by these incredibly hardworking, strong women, and I think that definitely had an influence on the way in which he raised me. For example, my father never raised me as a girl. I have to say, there was never a sense that my possibilities were at all limited by gender in his mind. I never felt there was any difference in the way in which he raised my brother and me—none at all. His attitude about gender has helped me in the marketplace because I've always felt that I could do anything, and I have.

When I left the Whitney Museum of American Art in New York in 1998, it came at a time of great transition for that institution. My departure was documented and analyzed in the press, and lots of opinions were offered, separate from me. In that moment my father was extremely helpful in keeping my mind off of it, by not talking about it. My father reads four newspapers, so in any other situation, we'd discuss something like that. He completely didn't say anything. Then, when I did want to talk about my next steps and what I wanted to do, he did not have the typical parent's hysteria about the fact that I was unemployed. He was not concerned at all. He said, "I know you're going to get a job. The question is, what do you want to do now?" He was incredibly supportive.

I think my father has always been proud of me, and I don't think it's so achievement-based. He is just happy that I am a happy person doing something that I love. My father definitely had to work hard to achieve many of the things he did when he did them, but he never speaks about it in that way. I think he sees that all of his efforts were so that I could do the things that I do now, and that's when I think he is most proud.

THELMA GOLDEN

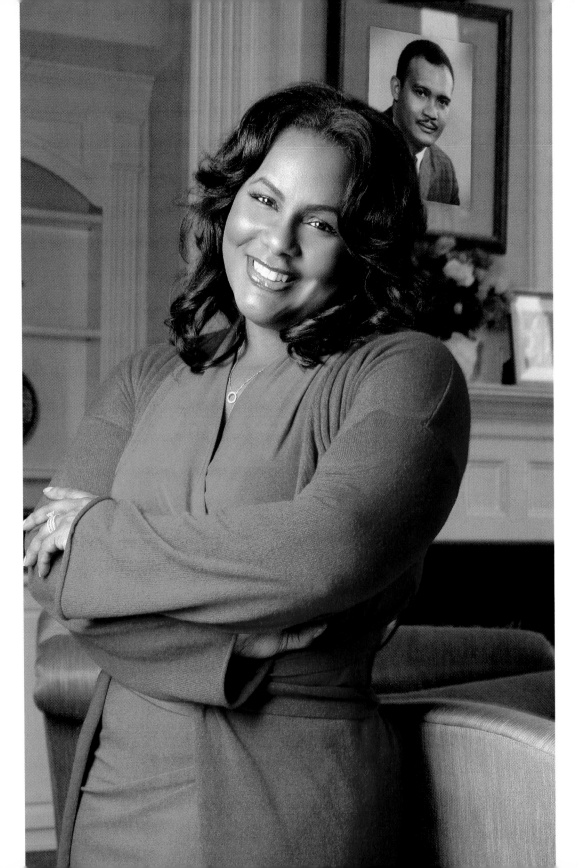

Chrystal Evans-Bowman is a clinical psychologist in private practice in Los Angeles. She has regularly appeared as a consultant on various television shows, including Fox's *Black. White, LEEZA,* and *The Ananda Lewis Show,* as well as *ABC News* and *NBC News.* Her father, Theodore Evans, was a dentist in Los Angeles who died in 1994.

Gentle Kindness

My father's name was Theodore, but he was "Teddy" to his friends and "Uncle Ted" to mine. Everybody loved my dad because he had an easygoing, welcoming nature. He was a true intellectual who would analyze anything and playfully argue it to the hilt. He encouraged me to prove what I thought to be true, and he would challenge my thinking in a loving, funny, and sometimes sarcastic way. Countless times, I would sit next to him on the couch, his arms draped around me, engaged in these kinds of discussions.

I was twelve years old when my parents separated, and my primary contact with my father was visiting him at his dental office after school. I would complete my homework with him, then help him around the office. He was a hardworking man who was very proud of his profession. I would watch him deal with patients, complete his charting, and manage payroll and client billing—and he used these opportunities to teach me about having a good work ethic. After we had dinner, usually at a neighborhood restaurant, he would drop me off at home with my mother.

My parents each promised that although I would live with my mother in our same home, nothing would change my close relationship with my father. I would still see him daily at his office after school, and I would spend alternate weekends with him at his apartment, which was only five minutes away. He and my mother together made good on this promise. My

father was always there: every birthday, every Christmas, every Thanksgiving. He never let anything get in the way of loving me. My parents used to say, "You are an only child, but not a lonely child." It was true.

My father was an outdoorsman, so I went hunting and fishing with him several times a month for most of my childhood. As bizarre events go, when I was nine years old, my father and I were once shipwrecked on a deserted island in the Sea of Cortez in the Gulf of Mexico. Our fishing boat battery died, and rough waters and approaching night skies forced us to paddle to a nearby island until daybreak. Hoping that other boaters would see us in the morning and help us get back to shore, we hurriedly packed the lifeboat with a gallon jug of water, a can of corn, my daddy's pocketknife, two bedsheets, matches, and a few other items. We spent the night on the island, and at daybreak we saw that our boat was nowhere to be found—just vast open sea, with hundreds of whales leaping in and out of the water.

As frightening as this was, my father remained thoughtful and calm as we tried to make sense of everything that was happening. I remember asking, "Daddy, are we going to die?" He responded, "No, Baby, we are not going to die," and I somehow felt safe. Many years later he told me that he had no idea at the time how we were going to survive. I remained calm because my father did so, and after three days we were rescued. Looking back, I realize that he never faltered in protecting me—from both danger and fear. To me this is the true mark of a father—a man!

He never tried to be successful. All that my father did, he did because he wanted to, not because others would be impressed. My daddy taught me two important things: to treat people the way I would have them treat me, and to be there for others when they need you. As a result of my father's influence, I chose clinical psychology as a profession. Now that I'm in private practice, I think of all the things he taught me—the practical things about billing, charting, and maintaining a good bedside manner with patients. My father had such a calming presence that he was able to put his patients at ease. I use his gentle kindness as a guiding rule in my practice as well.

When I was in ninth grade, I auditioned to give the graduation speech after a class assignment where we had to write an essay on the topic "What My Graduation Means to Me." As a result, I was the first African-American to deliver the graduation speech at Paul Revere Junior High School in Brentwood, California. Speaking in front of an audience of over nine hundred people, I received a standing ovation, and my dad was speechless with

pride. I think he was equally proud when I graduated from Howard University and then from graduate school at Pepperdine University. He died while I was in my last year of graduate work for my doctorate degree. I know he would have beamed with pride to see me become Dr. Evans.

When my father died, I looked at his life in total and realized that I was always proud to be his daughter. My husband and I named our daughter Evan, after my father. Since I am an only child who's now married, it's nice to know that his name lives on through her.

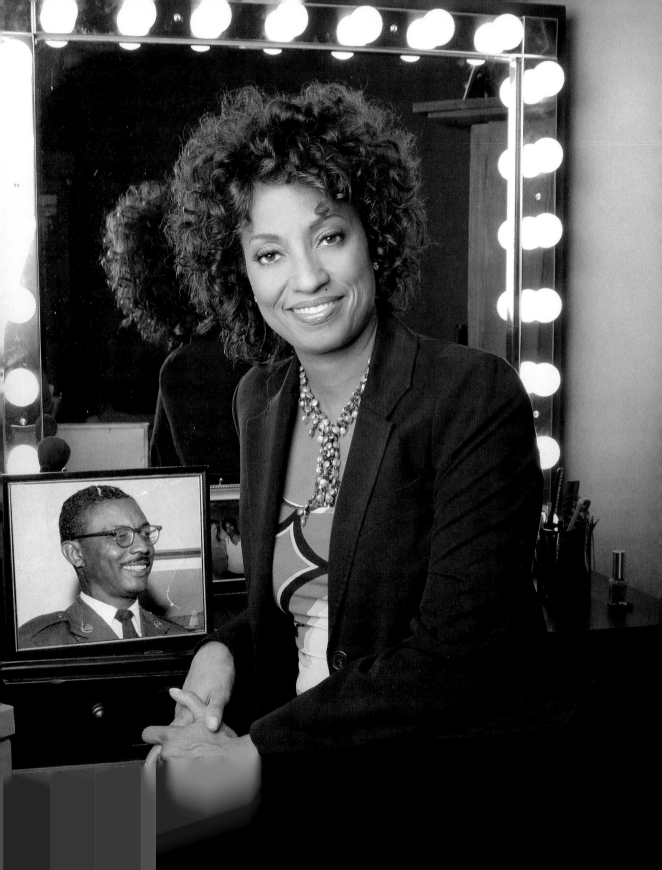

Rene Syler is the author of *Good Enough Mother: The Perfectly Imperfect Book of Parenting*. She served as cohost of *The Early Show* on CBS from October 2002 until December 2006. Her father, William Syler, an Army sergeant, died in 1990.

A Solid Foundation

My dad was always a really great provider. He made sure that his family was taken care of, and I don't mean just the physical needs. He was there for us emotionally as well. I cannot remember a time in my childhood when I had a want or a need for anything.

One Valentine's Day, when I was about eleven years old, my father had a second phone line installed in the house, unbeknownst to my sister and me. My dad said he had to make a quick phone call, and the new phone rang inside the house. Well, my sister and I just flipped! We went tearing into our room, and he had had this little princess phone installed. That was the kind of thing that my dad did.

He encouraged us by being an incredible example of what it was to be a working, productive member of society. That you go to work, pay your taxes, pay your bills on time, save money—things that seem basic and that you shouldn't have to tell people, but things that a lot of times people don't get. He always encouraged my sister and me to get a good education and to go further than he did. My father was a brilliant, brilliant man. He just didn't have the money to get a degree.

My father was a longtime civil servant. He was a master sergeant in the Army, then he became a mail carrier, and then he went to work for the Social Security Administration. I was proud of him every day. Looking back on it now, every day that he got up, suited up, and went

to work—that made me proud. It's hard sometimes as a black man, with all the baggage that goes with that experience in this country, to keep going. Sometimes I know he had the weight of the world on his shoulders, but he continued to get up and go.

Both of my parents really hammered home the whole "this is what it's going to take in life to be a success" message. My father in particular helped me understand goal setting. Targeting something and then taking a step back and laying the groundwork to get there. That was one of the great things that my father did for me.

I remember that my dad had these huge headphones—now, this was back in the early '70s—and he had this favorite chair. He would sit there and listen to Marvin Gaye or Ray Charles with the headphones blasting, tapping his toes. It was in that same chair where he sat years later and suffered a stroke. I ran up to him and said, "Dad, are you okay? Are you okay?" He couldn't respond because the stroke had paralyzed his ability to speak. It was a scary time, and that's when I realized that my dad was not in the best of health. The stroke was followed by breast cancer, diabetes, and heart disease—which ultimately took his life. He was a very sick man from the time I was about ten to the time of his passing when I was twenty-three.

I went to school in southern California for one year, and then I came back home to Sacramento to live with my dad. When I got back, he was very, very sick. I took care of him for the last year of his life. I would go to school and come back and sit with him in his hospital room. I don't know if he knew I was there, because we don't know what stroke victims know and can remember. Nonetheless, it was important to me to sit by his bedside and just be there.

One day I went into his hospital room, and he had lost so much weight that his wedding ring had slipped off his finger. It was under the hospital bed, so I picked it up, and I said, "Dad, I'm going to take this with me for safekeeping." After he died, I had the ring melted down and recast into another shape, and I still wear it. I have a part of him with me whenever I have that on.

Looking back on it now, I don't feel like anything was left on the table when my father died. I feel like we had a good, full relationship with each other. I don't have any regrets. I only wish we'd had more time together. Sometimes I think about the fact that he never got a chance to see me get married or that he's never seen my children, and it's kind of sad. He died

when he was only fifty-nine years old, but I have to say that he packed a lot of living into that fifty-nine years.

My father's legacy was that he worked hard to enable us to have a good life. When I look at the success that I've achieved, it is because he laid a good solid foundation for me. I believe he would think it's who I am, not what I do, that makes me a success. I think he would be proud of the woman I've become.

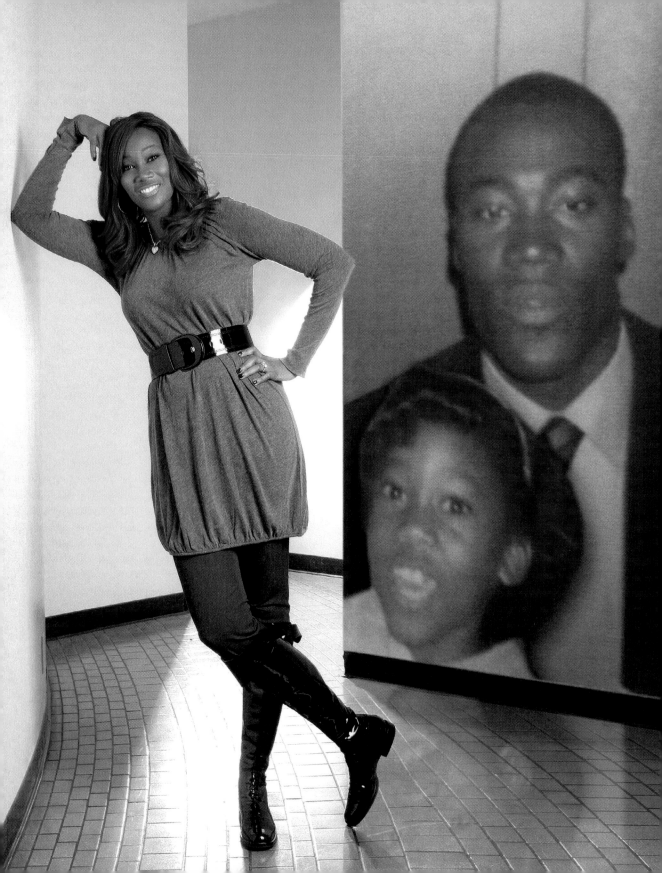

Yolanda Adams is a Grammy Award–winning, platinum-selling gospel recording artist. She also hosts a nationally syndicated radio program, *The Yolanda Adams Morning Show*. Her father, Major Leon Adams, was a middle school teacher and coach who died in 1975.

A Blessing to Everyone

Fatherhood was the most important thing to my dad. He was a very hands-on dad who loved his kids and loved life. He was just phenomenal. There were five of us then, but we all got our time in with him together. He was always willing to help with anything that we were doing. If we said, "Dad, I need help with this," it was never, "Go ask your mom," but always "What can I do?" Somehow he always had enough time, and there was enough room for everybody.

He always told me that I could be anything that I wanted to be, and he was a prime example. My father was the second of ten children and had to begin working at an early age. He came from a very poor background, and he didn't want his children living the way he did growing up. He was a teacher and a football coach for a junior high school team, and he was very business-oriented, so we rose to being middle-class as a result of that. For example, he was one of Amway's top salesmen in Houston. My father was the first of his siblings to finish college, then he got his master's in psychology, and he was planning to start working on his doctorate when he died.

It was understood in our house that education was important. My dad expected that every one of us would attend college, from the first to the last, and we all have our degrees

today. He taught me practical things like how to balance a checkbook and how to set up a budget. He also taught me how to save my money if I wanted to buy something special.

Dad believed that you shouldn't spend just because you have. If you want a pair of shoes—now you've got to remember that this was back in the '70s—and they might've cost around thirty-five dollars, you have to make sure that you have at least one hundred fifty to two hundred dollars in your account so that you have enough for the things that you need. He also taught me to question my spending. How many pairs of shoes do you have that look sort of like that pair? Is the new pair really necessary? I go back to that even now as an adult.

He would often say, "You're extraordinary, but never too extraordinary to turn your nose down on anybody else." He taught all of us that. That we were extraordinary because we came to this earth for something that God wanted us to do. Still, we were never to look at people and think that they were less than we were, or talk about people who had less than we did, because he remembered being in that position.

Success to my dad was treating everybody well and being a blessing to people outside of your household. He believed that God gives people success so that they can help others. My dad was the second oldest in his family, and he helped his eleven brothers and sisters get through high school and college. I saw this same philosophy in the way he treated his athletes. There were some young guys who didn't have fathers in the home, and he would spend time mentoring them on the weekends. They would come to our house, and he would teach them how to tie a tie, or teach them about business—things like that. He would play street football with the kids in our neighborhood—throwing the ball to them and showing them plays. He was a cool dad. Everyone loved his sense of humor, his warmth, and his love for people, too.

My dad absolutely loved athletics. He was a college track star in Houston when he attended Texas Southern University. When we were growing up, he played golf on the weekends with my grandfather, and he was part of a basketball team of older gentlemen. He was not just a "go to work and come back home" kind of guy. He was very active in the community, and he was active in our church. It was as though his lifestyle exhibited what he felt about life. He just felt life was good, worth living, and that you should live life to the fullest every day. But despite everything that he did, family still came first.

When I was thirteen years old, my dad passed away suddenly as a result of a car accident. He was in a coma for three months before he died. It may seem strange, but my faith actually

grew following my father's death. When the will of God is in operation you have to accept it. I had to believe that God didn't make a mistake.

Not being able to talk to him and not being able to have him see me on prom night was difficult, but I'm grateful that he gave me such a strong foundation while he was here. He taught me so much that I still use today. Like not giving up just because it didn't work the first time. Or that you can do anything that you set your mind to. Or that you're much stronger than you realize. When somebody consistently tells you these things, they come back to you when it counts.

I believe my talent for singing came from my father. He had a beautiful voice, and although I didn't know then that I'd do it professionally, he definitely heard me sing before he died. There are times when I wish he was here to experience my successes—the Grammys, the awards, and the gold and platinum albums—because he taught me well. I know that he would say, "You did good, girl."

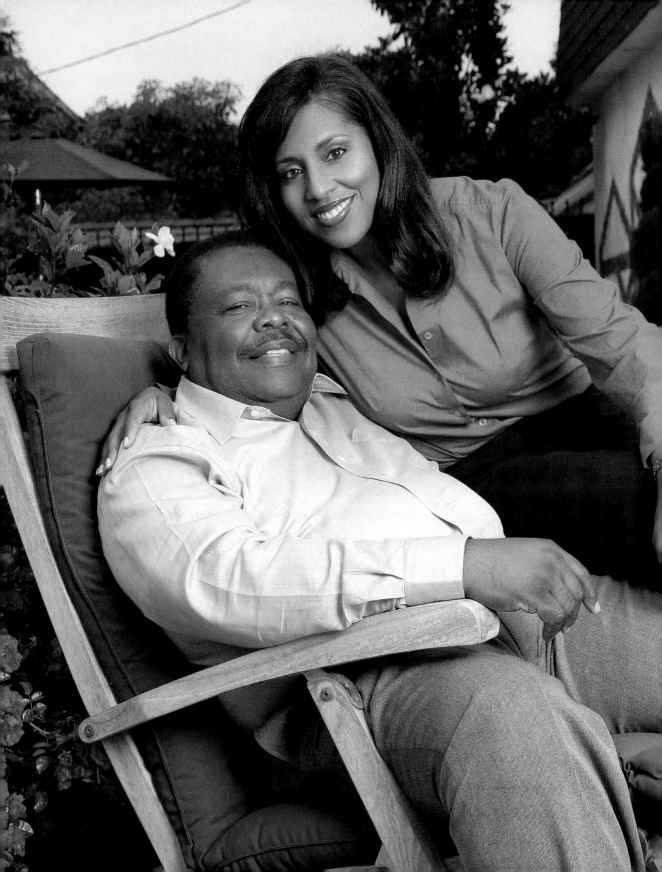

Andrea Nelson Meigs is a motion picture talent agent with International Creative Management (ICM) in Beverly Hills, California. She represents singer-actress Beyoncé Knowles, R&B singers Mary J. Blige and Chris Brown, and acclaimed actor Idris Elba (*The Wire, Daddy's Little Girls*), among others. Her father, David Nelson, is a retired school administrator who lives in Palos Verdes, California.

A Can-Do Man

One of the things that I developed from my dad is a love of real estate and houses, because real estate is his hobby. My brother and I would get in the car with our dad in the morning and literally drive until the sun went down, looking at properties. When we were older, my father would teach us how to collect the rent and do repairs on his income properties. We'd landscape them and paint the units when there was a vacancy. He even taught us how to install windows, hang blinds, and buy curtains. My dad was just a property buyer when we were younger, but over the course of time he got a real estate license and became a broker.

My dad is a workaholic—he is always doing lots of things. He worked for the school district, managed real estate, and coached on the side. At one point my mother had three or four jobs, so she worked hard as well. We never took vacations growing up. My parents, who have been married more than forty years, never took anniversary trips, and they never had a honeymoon. I guess one of the reasons I've been successful is that I have a very serious work ethic too. I learned that from watching my parents.

At a young age, my father taught me that the word "can't" doesn't exist. That word was not in our vocabulary, so we could never say "I can't" do something because he would tell us

to find a way to do it. Interestingly enough, that didn't just apply to my brother and me but to my father as well, because my parents didn't have a lot of money. Nonetheless, they found ways to make things happen. For example, if I wanted to go to camp or if I wanted to go study abroad and my parents didn't have the money sitting in an account, they would figure something out. They'd either take a second mortgage, get another job, take out a loan, or figure out another way to pay for it. The rule didn't always come down to a financial issue. I remember not getting into law school the first year I applied. So I had to figure out a way to make it happen. I visited the school I wanted to attend, introduced myself to the dean of admissions, and really made an effort to understand which classes were important to the admissions committee. The next year I reapplied and was accepted into Duke University Law School—a top ten institution.

I think my father was most proud of me when I graduated from law school. His goal in life was for his kids to go to college and to graduate, so when I went to law school that was huge. He was just beaming. Both of my grandmothers were alive then and able to come to my graduation, so it was not only that my father witnessed the event, but that he was able to show my grandmothers what he had accomplished through me. For him it was like, "I've been a good father, and I provided for her. Now look at what your granddaughter has done!"

I started off at Creative Artists Agency (CAA) in an entry-level position in the mail room—and this was after going to college, going to law school, and working at the Los Angeles district attorney's office. Most of the people in the mail room with me were people who were straight out of college and had never had a job before. Also, when you start out at CAA they tell you that there are no guarantees that you'll become an agent. You can go through their training program and still not be an agent after three to five years. But I'm an optimistic person. I kept thinking, *Well, I'm older, I've got work experience, I work really hard, I'm a woman, I'm African-American—all these things are going to help me in my ascension here.* I thought it would be quick, but it took me almost four years to become an agent. I never said the word can't.

Growing up, most of my friends came from two-parent households. When I got to college, it was a real eye-opening experience because I met so many female students who didn't know their fathers. Some had lived through their parents' divorces, and some had had incestuous relationships with the male figures in their families. This was so foreign to me that I couldn't believe it. I just assumed—naively, obviously—that my family was the norm. When I realized that it wasn't, I felt really blessed because my dad was always there. He was at my track

meets, my dance performances, every tennis match, speech contests, every recital—he was even there when I gave birth! I could always count on him, and I think that's how I learned what being a man is. Someone you can rely on, someone who takes care of his family.

What I love most about my father is that he makes me feel like I'm the most important thing ever. He's my best friend, and I talk to him every day. When I need motivation, I talk to my dad. When I need to be inspired, I talk to my dad. When I'm angry, I can call my dad and he will calm me down. I can call him if I'm having a bad day, and I can say, "Hi, Daddy," and he knows exactly the kind of mood I'm in just from hearing me say those words. Whenever I call, he never says, "I can't talk to you right now." Never.

I know where he came from, and I see where he is now, and I admire it so much. He grew up in St. Louis, Missouri, with five brothers and sisters. His mother used to clean "white people's toilets" and only had a third-grade education. He recalls a situation when he was in a bar with some guys and guns were shot. He told me that at that moment his life could have gone in either direction. He thought to himself, *I don't want this life. I want something better for myself.* Later he joined the Marines, came to Los Angeles, got a college degree, worked in education, and went on to get his master's. Then he became a real estate agent.

When my dad was younger, he used to ride forty miles on his bike on Sunday mornings all through the hills of Palos Verdes, California. It's on a peninsula, so if you've never been there, it's almost like a half-circle that sits out on the ocean, and it's incredibly green and beautiful. It's almost up in the mountains, and there's no smog, and the homes there are really gorgeous. Some of them are on the cliffs and have these amazing ocean views and city views. My dad would ride through this neighborhood all the time and dream about living in one of those homes. He said to himself, *One day I want to have a family and live here.* Now my parents live there!

We all dream. What I learned from my dad is that you have to set your goals, work toward them, and never say, "I can't." Chipping away little by little if you have to because things don't always happen overnight. Knowing his beginnings, I find it amazing that my dad now owns several properties and that he lives in Palos Verdes in a beautiful home. He's got a wonderful and loving relationship with my mom, and I just admire him so much. I just look at this man and think, *He did it. He really did it.*

ANDREA NELSON MEIGS

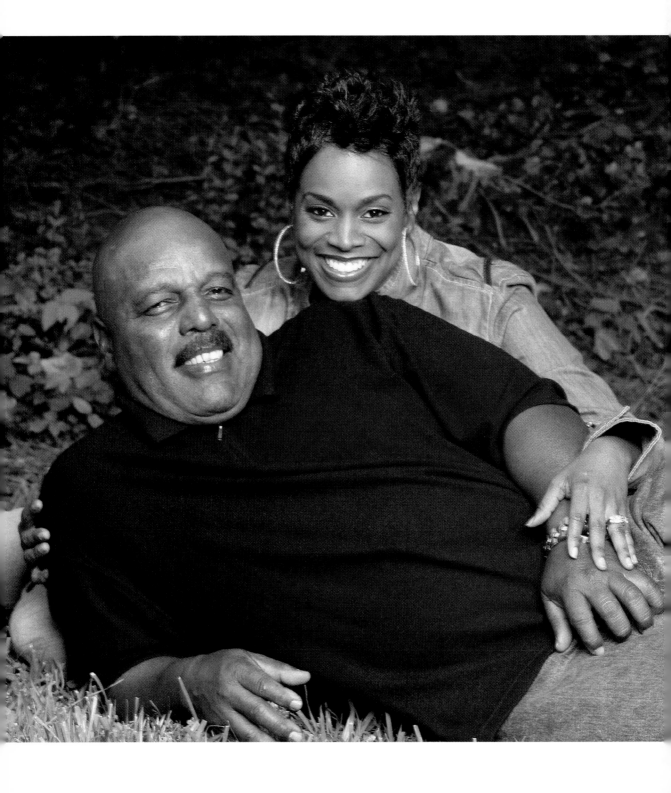

Rashan Ali is host of the top-rated *A-Team Morning Show* on Hot 107.9 FM in Atlanta, Georgia. Her father, William "Buck" Godfrey, is the head football and swim coach at Southwest DeKalb High School in Decatur, Georgia.

Quiet Conversations

I have always been a daddy's girl. When I was three, my father gave me this nickname, "Fats." I had the biggest cheeks and these bow legs—my dad is bowlegged as well—and he decided to call me Fats. I remember just loving my dad. My father always told me that I was beautiful, so I never doubted that I was attractive. He still calls me "Pretty." He's a high school football coach, but he was also an English teacher, and he's a poet. He has a master's degree in linguistics and is just a beautiful writer. He always wrote about me and my complexion and how things were when I was born. I always wanted to be near him. Everything he did I wanted to do.

My father had summers off, and we would go to Stone Mountain Park, which was the thing to do back then. We would go to Charleston, South Carolina, my father's hometown, and go fishing. I knew how to bait my own hook and catch my own fish at a very young age. He also taught me how to crab. We'd get a big bucket, scoop up the crabs, and take them back to my grandmother's house. Then we'd boil them and sit there eating crabs all day. I grew up a tomboy doing everything from fishing to crabbing to anything sports-oriented. Daddy is the winningest high school coach in DeKalb County history, so I was always around football. I was just like the little white girl in the movie *Remember the Titans*. That was me! If my dad's team lost, I would cry. I was the girl who stayed on the sidelines with my dad the entire way. I wanted to see him coach and be successful and win!

My daddy was also a competitive swim coach in the summer league when I was a little girl. At that time only little boys my age were swimming, so I had to swim against them. Once when I was five years old I was swimming the 25-yard freestyle and I became very tired. So I pulled over to the side of the pool to get some rest, and my dad knocked my hand off the ledge and made me swim. He said he would never forget the look in my eyes when he did that. I thought, *How could my daddy be so mean?* It taught me fortitude. It taught me to keep going even when things got rough. He hated to do that but knew it would build character in me.

He was most proud of me when I was eight or nine years old and our swim team broke the 100-yard medley relay record. He always talks about that. We were the only black people there, the only black girls swimming. When we won, he had all four of us girls in his arms. He said that it was better than when he won the state football championship in 1995. We broke around ten records and about half of them still stand in DeKalb County, Georgia, today. He knew how to develop us to become great. You just wanted to be the best because he expected you to be the best.

Everything my dad did, he did well. Everything he touched turned to gold. He taught me how to win, so even in my career now, I have to win. My goal with *The A-Team Morning Show* is to be the best, to beat everybody else in the Atlanta market. Losing is never an option. You have to do what you need to do to become number one.

My father has strong faith, and he loves God. He has this green Bible that he's had for as long as I can remember. He studies that Bible and knows it back and forth. He prays and spends time with God. He doesn't outwardly shout, "Praise the Lord!" but he'll say things like, "Go to God in prayer," or, "God will take care of it." He'll say it, but you don't have to hear it all the time because he shows it in his actions. He's been a father figure to so many young men. I shared my father for as long as I can remember because many of his football players lived with us. One of my father's mottoes in coaching was: "You bring me your boy, and I'll send him home a man."

When I graduated from college, I really didn't have any sense of direction because I'm so creative. I had a broadcast journalism degree, but I was working odd jobs. For a while I worked at the board of education, then I worked as a personal assistant for Left Eye from TLC, then I worked at LaFace Records. I was just trying to find myself. I lost my job at LaFace when L. A. Reid and Babyface sold LaFace to BMG. I thought to myself, *Man, when is*

everything gonna turn around for me? I would talk to my dad about that and cry. He would sit there and listen and say, "You've got to pray and you've got to believe that things are going to change." Once I allowed my heart to believe that, they did. Things drastically changed in my life once I started to believe and accept where God had me at the time, and when I decided to walk by faith and not by sight.

Once the opportunity to host the morning show came about, I was so scared to step into those shoes. I didn't believe in myself enough. I was young and had only been in radio for three years, but God had a bigger picture, a bigger plan. Now when my dad listens to me on the radio and hears my maturation, I think that he's very proud of the woman I've become. All of that came from those quiet conversations we had. Not a lot said, but so much communicated without words.

Girls need so much from their dads—from love to encouragement to that silent time that I love so much. A man to show you how to pick yourself up, to teach you how to ride your bike, to show you what to look for in a man. The reason I am the way I am is because of my dad. How can you describe a good father without saying William "Buck" Godfrey? "Good father" is who he is! I love his will—the will to do whatever he wants to do. I love his intellect. The fact that he can quote anything from Shakespeare to Edgar Allan Poe to Langston Hughes to his own poetry. He's a great man. I love the way he loves me.

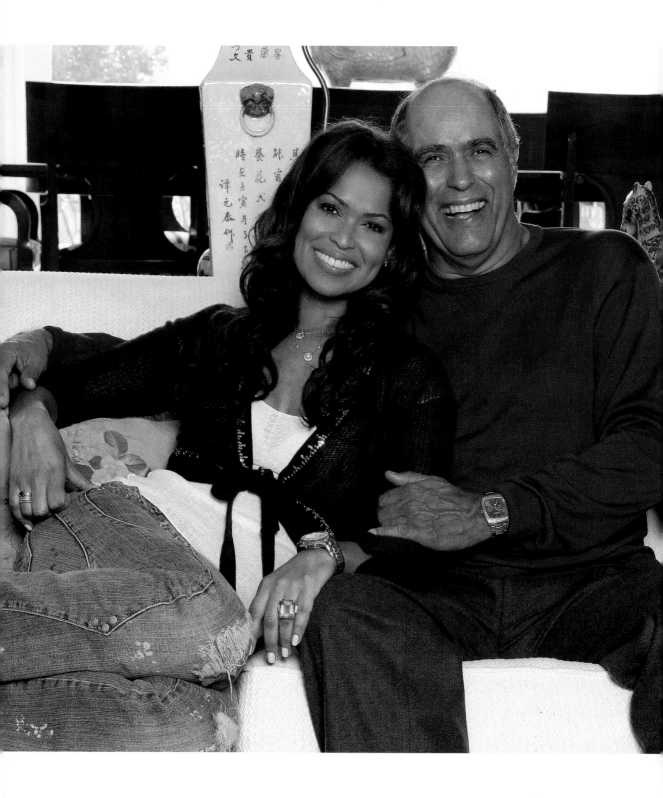

Tracey Edmonds is president/CEO of Edmonds Entertainment and president/COO of Our Stories Films. She has developed numerous film projects, including *Who's Your Caddy*, *Josie and the Pussycats*, and the television series *Soul Food*. Tracy also executive produced the *College Hill* and *Lil' Kim: Countdown to Lockdown* reality television series on BET. Her father, George McQuarn, is a retired high school and college basketball coach.

Actively Involved

My dad was kind of like the Chevy Chase character from the *National Lampoon Vacation* movies. He was always planning family activities, so we grew up looking forward to all the Christmas and summer breaks because my dad always had some really fun trip planned. He would pack up my brother and me with my mom, and we'd go up the coast of California or on camping trips or to the Grand Canyon. He would always go to AAA and map out the freeways with his yellow highlighter. So I have very visual memories of those trips because we always had a really, really great time.

When I was growing up, my father was a high school basketball coach. He was amazing. His team won the state championship every year that he coached. I remember we had a family room with a trophy case, and it was just loaded with all of his trophies. Since he did so well in the high school arena, he was offered college basketball coach jobs and eventually became a basketball coach at the University of Nevada at Las Vegas, where his team went to the national championships.

My dad and I are very, very close, so he reads everything that he can find in the press about me and my industry. He's a very detail-oriented person, so he asks me specifics about

the movies that I'm doing, and he wants to know the intricacies of how my business works. He will ask about issues that are happening on set, or he'll ask about how something has been edited or how the preparation for a premiere is going. My dad still has that coach mentality, so he's a straight shooter. He's the type of guy who will say, "Tracey, make sure, whatever you do, that you hire good people. You may be approached by friends who want jobs, but you make sure they're qualified." He'll go see an independent movie and he'll tell me, "You need to go see *Little Miss Sunshine*." Or, "Go see *Farenheit 9/11*." He's very intelligent and always has a strong opinion, which I appreciate.

My father is good at maintaining relationships, so many of the people that he worked with in the 1970s when he was coaching at UNLV are still in his life. I've applied that same philosophy to what I do. For me, networking is really important. My father taught me that when you develop close relationships, those are the people who you can pick up the phone and call if you need a favor or if you're in a bind.

I've always viewed my dad as a winner. He's somebody who was constantly accomplishing things, so I greatly admire him, and I still seek out his advice. I'll tell him if there's a particular predicament that I'm in—maybe a political situation or something that's going on within the business—and I'll say, "Dad, what would you do?" He always tells me to keep my priorities in line. He says, "I don't care what's happening behind the scenes with business, or what is going on in your production, always think about the kids." To him, it's all about his grandchildren.

He lives in Las Vegas, but we see him at least one or two weekends a month. He has the same attitude with my boys that he had with my brother and me—that Chevy Chase thing. He'll come to the door with a loud knock and say, "Hey, Brandon, Dillon, get your stuff together, we're going to *hang*!" He'll take them to a movie, he'll take them to the toy store, he'll take them to lunch, he'll take them bowling. He's a wonderful grandfather because he's still very active—and he never misses anything—birthdays, school plays, camping trips— he's always there.

My dad grew up in a rough part of South Central Los Angeles. He had a tough time because he lived in the projects and he had to try to stay out of gangs. The gangs harassed him because he was different-looking—he is very, very fair-skinned and can look almost as if he is white. I remember the stories that he told me, like when he had to walk through belt lines—two rows of people you had to walk through, and on one side there were guys with

baseball bats, and on the other side there were guys with chains and belts. I would break down and start crying. It was pretty brutal, crazy stuff, but he focused on athletics and getting good grades, and as a result he ended up getting a college scholarship to UCLA and he got out of there. Anybody who can go through that and not be psychologically disturbed has got to be a really, really strong person. I think those experiences just gave him the drive to succeed.

My parents had a rocky marriage, and they finally got divorced when I was a senior in high school. I felt really fortunate that my dad remained so involved with us. After my parents separated, no one ever had to remind my dad that it was his week to keep the kids. Same as with his grandkids, my weekends with Dad meant we were going to go see a movie, go miniature golfing, or that he was going to take us fishing—because he would always be very interactive with us. It was never that he was on the phone the whole time and my brother and I had to entertain ourselves.

He's brave. I don't know what he pulled from, but my dad came from really humble, rough beginnings and made a success out of his life. Career-wise he was successful, and he raised two positive kids. He gave us the foundation we needed to ultimately have success in our own careers, and I respect that about him.

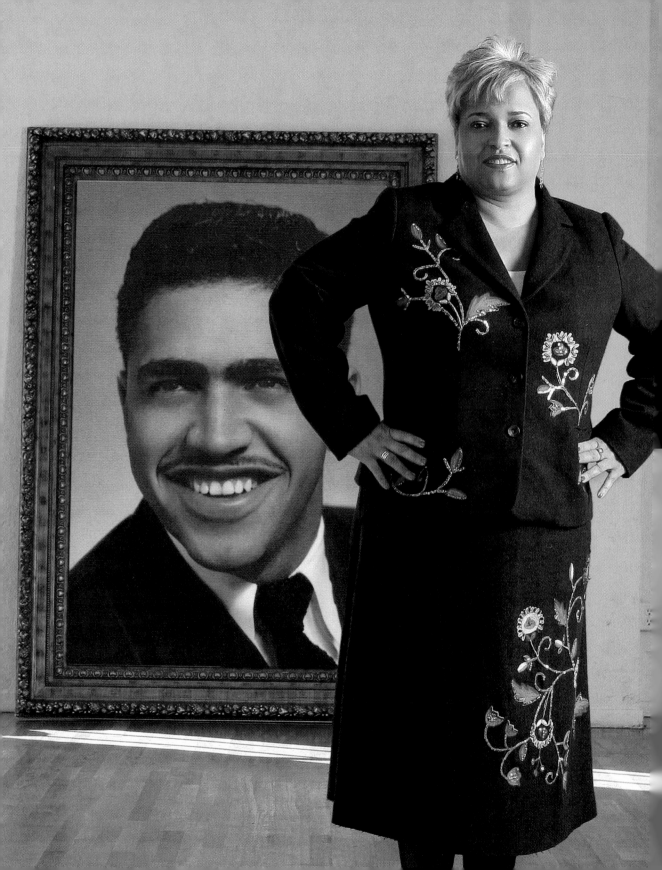

Kathy Johnson is president of the National Association for Multi-ethnicity in Communications (NAMIC), an organization that advocates for the cause of diversity in the telecommunications industry. As president, Johnson oversees the daily operations of NAMIC and its seventeen chapters nationwide. Her father, Ken Johnson, was a chef who died in 1989.

Cooking Up Life's Lessons

My most vivid memory of my father is of him teaching me to ride my bike. He was very athletic, so he always had me riding a bike, going swimming, going to the tennis court—anything to keep me active. He also taught me how to play chess.

My father was a chef. When I was a young kid, he headed up food services for the local YMCA. In later years he taught culinary arts at a local community college, and he had his own catering business as well. My father was one of those people who felt that if you weren't working, being useful and productive, you were just taking up space.

He began cooking when he took home economics in high school. Dad was the only boy in his class! When he graduated from high school, he moved to Des Moines, Iowa, where I grew up. My father was very intelligent—he skipped two grades and graduated from high school at fifteen—but he simply didn't have the money to go to college. He started working right out of high school and was very independent from an early age. He enjoyed catering because it allowed him to be self-reliant, to generate income without relying upon others. Also, catering combined his two loves, cooking and entertaining, so it was the best of both worlds.

Mostly my father catered private parties and corporate functions—typically for white

people. He was pretty much a one-man show, although he often hired extra people to help out with the serving, and he'd sometimes stay to provide bartending services. One thing about my dad is that if he met you six months ago at a party and you said you were having a vodka tonic, when he saw you six months later he would say, "Mrs. Smith, are you having a vodka tonic tonight?" Since he had a photographic memory, he remembered people's names, faces, what they drank. People really liked that about him. Sometimes when he would tell a client that he was sending someone else to work their party, they'd say, "Oh, no, we want you!" He had such a great personality.

My father was very jovial—a jokester I would say. When I was in high school, I worked in the grocery store and my dad came in one day. He went over to a woman I worked with who didn't know he was my dad. She was white, and I was the only black cashier working at the store at the time. He said, "You let that girl work here?" and he started complaining about me. The woman got really upset because he kept going on and on. Finally, he said, "That's my daughter," and she was so relieved! He always had a good time. Often you could hear my dad laughing before you could physically see him!

Another classic moment was when I was living in South Orange County, California, which was pretty much an all-white county. When I first moved there seventeen years ago, people would stop in their tracks when they saw a black person. During one of my dad's visits, we went to a little takeout restaurant in the neighborhood. The cashier was just standing there staring at my dad with her mouth open. My dad said to her, "What's the matter, honey? Haven't you ever seen anybody from Iowa before?" He was always able to make his point without being nasty to people.

Every year we would take road trips across the country because my parents were big on traveling around and seeing America. My dad came from a large family—he was one of six, and his mother was one of six—so we would stop and see his many cousins and other family and friends. In 1959 my parents drove to New York and to Washington, D.C. They were not able to get a hotel in D.C. because they didn't let black people stay in hotels back then. They would share stories of segregation with my sister and me, and we were very mindful that it existed, but they still encouraged us to be around diverse types of people and have friends of different ethnicities. It's interesting that I do diversity work now. My father passed away before I began working at NAMIC, but I think he would like what I'm doing because diversity was very important to him. Life was about being a good person and treating people with respect.

As I recall, my father always had different types of friends. He was a "live and let live" kind of person—in some regards, a hippie type—who was easygoing and accepting of all. His core group of friends and family, of course, were African-American, but he always had lots of other friends who weren't. Dad always made sure that different people came over to the house. To him it was a measure of how sincere people were about diversity. You know, people could like you socially or they could like you at work, but did they like you well enough, think you good enough, to invite you to their home? That was always his test. Also, he was naturally curious, so he found it interesting to learn about people from different cultural backgrounds.

He always said that success is doing something that is financially rewarding and that you enjoy. As an entrepreneur, my dad was very much a proponent of making sure people were happy in what they were doing at work. He believed that since we spend inordinate amounts of time at work, we should be happy with what we're doing on a day-to-day basis. I always keep that in mind in terms of working with people and building teams. I try to create a friendly environment at the office that's inclusive and fun so that people don't feel stressed out just by virtue of being in the workplace. The work itself sometimes can stress you out, so in my mind you shouldn't have to deal with a lot of other stresses or issues.

My father made a lot of sacrifices to ensure that I had the education that was not available to him. I never really had the opportunity before to publicly acknowledge my father. He had a strong work ethic, good family values, and believed that his children should have opportunities that he didn't have. You hear so many negative things about African-American men, but I wouldn't be where I am today without the sacrifices my father made for me.

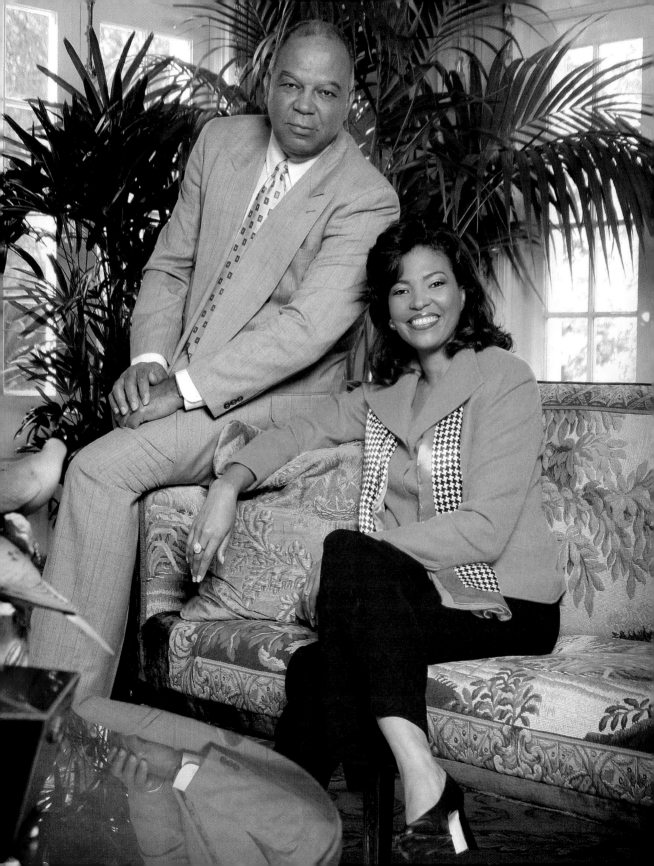

Kim Hunter Reed, PhD, is executive vice president of the University of Louisiana System. She formerly served as deputy chief of staff for the office of Governor Kathleen Babineaux Blanco of the state of Louisiana. Her father, Lawrence Hunter, a former high school teacher and coach, serves as personnel supervisor with Calcasieu Parish Schools and resides in Lake Charles, Louisiana.

The Encourager

My first memories of my father were of him coaching sports. He was a fantastic track and football coach, and I remember as a little girl always wanting to jump in the truck, go to practice, and cheer for the team. Having the opportunity to be a part of his occupation and to be involved in the spirit of competition was something I just loved.

He was always encouraging his athletes, whom he called men even though they were high school boys. He took care of them, checked on their grades, checked on their families, gave them a ride if they needed one—I mean, they really became a part of our family. I can remember being with him making sandwiches for the team so they'd have something to eat because some of his athletes were financially challenged.

To see him give so much of himself and to have concerns beyond his athletes' best time, play, or touchdown I think spoke a lot about him. He had high expectations for me as an only child, and he had high expectations for his athletes. It was very special for me as a girl to see my dad being a role model to countless young men. My dad had an incredible ability to reach out and teach you to do what you never thought you could do.

My father grew up in a single-parent home in the projects. His mother was a short-order

cook. She worked really hard to make ends meet, and she only had an eighth-grade education. Still, she knew that education was the way out of poverty, so she encouraged my dad to be a studious person and to seek opportunities. He went to college and played football at Grambling State University in Grambling, Louisiana. He was a left-handed quarterback for the legendary coach Eddie Robinson, and he played professionally for a very short time with the Green Bay Packers. He didn't talk a lot about that experience. At that time African-Americans couldn't go into some stadiums, and it was very difficult for him.

I rode to school with my dad every day, from pre-K until I graduated from high school. While we drove, he set the agenda for my day. Ever the coach, he'd give me my pep talk, call out my spelling words so that I could practice them, quiz me on facts for my debate, or make sure that I had the information I needed for my science project. He frowned upon anyone else taking me because that was our cherished time together.

I always joke that my mom taught me about domestic travel and my dad taught me about domestic life. My mother was an executive who sat on the national and state Head Start boards, traveled a great deal, and made her mark in the world. My father was always the person who was concerned about whether you were independent—whether you could clean, cook, change your tire, balance your checkbook. He grew up with the expectation that he would have to be a self-starter, so he had those same expectations of me. My dad was the first in his family to graduate from college, and both he and my mother had master's degrees. The expectation was that I would succeed in high school, graduate from college, and secure my master's. He wanted me to be in what he called "the master's club."

Over the years my dad has taught me a lot about dealing with adversity. He's been a brush-yourself-off-and-move-forward type of person—a very positive force in my life. He believes that even when things don't look great you can still overcome. Having a father who has taught me how to do deal with adversity has been a great thing as I've lived through Hurricane Katrina and Hurricane Rita and some of the other things that our state has dealt with during the time that I've served as director of policy and planning and now as deputy chief of staff.

When you have a dad like mine, you have the confidence to know that you can be successful. You have the confidence to go after positions where perhaps women, and certainly African-American women, have never gone. I think it puts you in a place where you feel comfortable getting into the game. You have the confidence that you're well prepared and well

educated and that you can perform well. Then you have the confidence to know that if things don't go well, you can get the pep talk. You have somebody who's going to understand and give you that word of encouragement when you really, really need it.

My dad has made a difference because he has not been selfish in his pursuits. He could have coached on the college level, he could have done other things. But he found what he thought was his calling, and he worked daily to do the best that he could in being a high school teacher and a coach. It doesn't pay the most, and it's not a position where you get a lot of thanks or recognition. However, it is certainly something we need more of—great teachers who make a difference every day and believe that young people can learn, meet their potential, and be their best. That's what my dad has been.

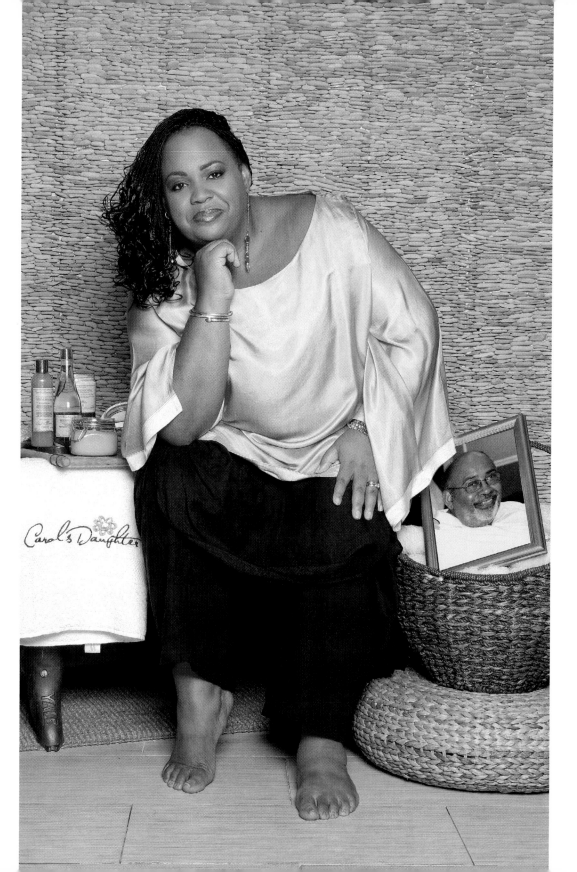

Lisa Price is the founder of Carol's Daughter, a beauty products company with celebrity investors such as Will and Jada Pinkett Smith and Jay-Z. The company has four retail stores in the New York City area, a thriving online business, and distribution with Sephora stores nationwide. Her father, Robert Powell Hairston Jr., is a professor of business law at Jackson State University who resides in Jackson, Mississippi.

Robert's Daughter

My father had a way of making you feel like there weren't any limitations. He would take me around New York City and show me his favorite streets and buildings in a way that made me feel there was nothing unattainable about it. For a long time I didn't have an awareness of what our economic place was. It wasn't until I got to high school and met people who really came from upper-middle-class families that I realized we weren't well off. I just always felt like I was a very well-off person. It's not like my father told us that we were, but because he exposed us to so much culture, I never felt like I lived in the box of the Brooklyn neighborhood that I lived in. I didn't realize I lived in "the 'hood" until I was nineteen, and then I was like, "Oh, is that a bad thing?" I always saw other things and did other things since we would always go on little trips together. We took trips to Washington, D.C., and to Philadelphia to learn about the history of the country. We once took a bus trip all the way to Montreal. I remember getting all dressed up with patent leather shoes and white gloves and going to Radio City Music Hall. Going out and doing and seeing new things with Dad was always fun and adventurous.

When I was in grade school, there was a boy in my class named John who picked on me. I was younger than the other students, so John would tease me and hit me under the desk

with a ruler. My father was looking at my homework one night, and in the back of my note-book there were notes that said, "Please stop!" and, "Don't do that!" He said, "What are these notes?" I started crying and told him, "There's this boy, and he picks on me, and I don't want to get in trouble with the teacher, so I write him notes to tell him to stop!"

The next day I was sitting in my classroom, and my father walked in with the principal. They spoke with the teacher, and the teacher just nodded her head, and my father walked back to the door. He just looked at John—never took his eyes off him. Then the teacher said, "Lisa, I need to rearrange the classroom because I'm having trouble seeing you. I need you to come sit right here next to Pamela." My father just kept on staring at John, and he waited until I picked up all of my things and took my new seat. Then he said, "Okay, Baby, I'll see you later. Daddy loves you!" and left the school. I thought, *My dad is great!* He was like Superman to me that day. After that John never said another word to me.

My dad advised me on things like always speaking clearly—he was a real stickler on grammar. He reinforced rules such as you don't end a sentence with a preposition, or he'd remind me that the word *ask* is not *ax*. Sometimes I'm in places and I feel like, "What am I doing here?" I've been on panels with senior executives of major corporations, and once I was on a panel with Iman. While I'm nervous and not sure how I ended up there, I know that when I open my mouth I'm not going to sound like an idiot. Part of that is because of my dad's strictness about grammar, vocabulary, and enunciation. He would make you say some-thing over and over again until you got it right. If you mispronounced something, he would say, "Oh Lord, the king's English. What are you doing?!"

In the very beginning when I started Carol's Daughter, I was working in television pro-duction on *The Cosby Show*. You have to understand, with my father there is Jesus Christ, Martin Luther King, and Bill Cosby. He was so proud that my name was on the credits, and he would always tell people, "My daughter works on *The Cosby Show*!" So after I started oper-ating Carol's Daughter full-time, he was a little disappointed that my television career was going away. Then when he saw that things started to pick up, he was fine. I think he is most proud of me now because he watched me build and grow my company and still sees the same person.

My father always pushed me to do the best that I could do. There was nothing that I couldn't achieve. I always felt like I had his support—he really spoiled me in a good way. He didn't spoil me in the "I'm gonna buy you everything under the sun" kind of way, but he

spoiled me in that I always felt that I was special, important, smart, and blessed. I never took having a father for granted.

Every day I know that I grew up with a dad, and I am watching my kids grow up with a dad because my father showed me what to look for in a husband. So often I think that people think black people just don't have fathers. They assume we only have moms, and that's really sad. I don't think that black men get enough credit for being really good dads. They get credit for being thugs, and they get credit for being mean or rich. Nobody applauds them by saying, "You did her braids today?" or, "You cooked dinner today?" I remember my father doing those things for me all the time.

The reason that I named the company Carol's Daughter is that it had a better ring to it than Robert's Daughter for a body care company, not because I didn't have a father in my life. My father taught me to respect myself and told me that I could do whatever I set my mind to do.

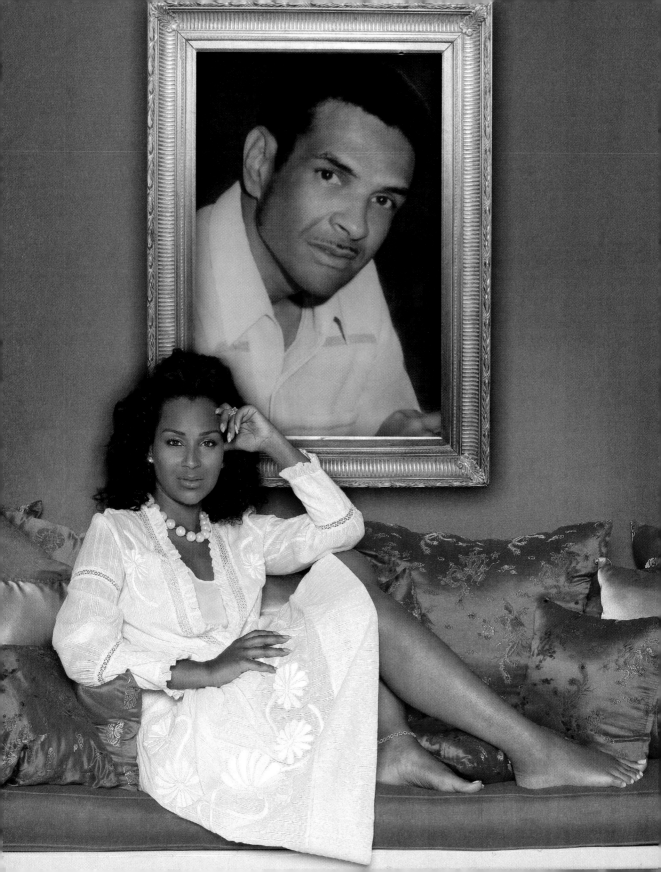

LisaRaye McCoy is an actress who recently starred in the CW sitcom *All of Us*. She has appeared in several films, including *Beauty Shop*, *The Wood*, *Gang of Roses*, and *The Players Club*. She is also the first lady of Turks and Caicos Islands, having married the nation's premier, Michael Misick, in 2006. Her father, David Ray McCoy, was a Chicago-area entrepreneur who died in 1988.

My Father's Daughter

I remember always being in the backseat of my father's car. I remember hanging out with him for hours and coming home in the wee hours of the night. We were together so much that I actually grew up in the backseat of his car. My mother used to make him take a pillow for me so I'd be comfortable when I fell asleep. I remember him taking me everywhere—business meetings, to run errands, visit friends, to dinner engagements. Just everywhere. I was definitely a daddy's girl.

My father was in real estate—he ran a chain of hotels and motels in Chicago called the Zanzibar Hotels. As a little girl, I assumed he just ran around and did a bunch of everything. I remember us going to a lot of buildings. A lot of construction was going on. I didn't know then that he owned these buildings and that he was renovating them. He was such an example to me because he was always managing a variety of projects at once, and I was able to watch him develop his business from the ground up.

As a result of helping my father, I have worked practically every job in the hotel/motel business. I was a housekeeper, a switchboard operator, a check-in clerk, and I did payroll and inventory. By the time I was nineteen, I was able to run one of my father's hotels. I went to

Eastern Illinois University for one year, studying hotel/motel management, and missed my father so much that I came back home. My phone bill was incredible just from talking to my father all the time.

My friends always knew that my father loved me an awful lot. They knew that I was spoiled, and he made no apologies about that. They'd say, "That's LisaRaye and her father!" If you saw him, you saw me. If you saw me, you saw him. I think our closeness came out of the loving relationship that he had with my mom and the fact that I was the product of their love. When people would see us together, they would say, "You are your daddy's child."

My father was in a wheelchair from the time I was one year old. He was robbed, tied up, and shot. As a result, he was paralyzed from the waist down. While he was in the hospital, my father made a conscious decision not to give up on life. He got his first hotel when he recovered, and that was when he started to make his fortune. It was as if the incident motivated him to work harder to succeed. By the time I was in high school, we owned twelve hotels, a car wash, a law office, car lots, a bank, a steel mill, a nursing home, a radio station, and a nightclub.

Education meant a lot to my father, but because he came from a big family that needed to be fed, he found it best to leave home and try to send money back for his siblings. He left home with fifteen dollars in his pocket. From there, with an eighth-grade education, he became a multimillionaire. It was amazing, the things that he achieved, because I often wonder how he learned so much. Who was his teacher? In eighth grade you're not reading contracts, managing bank accounts, or making multimillion-dollar deals. You don't know how to choose the appropriate business partner. You don't know any of that!

I remember when I started modeling professionally I had to build my portfolio, so I began taking lots of pictures. He was so proud that when I put my book together he carried it around in his car for about a month, showing all his friends and business associates. He was like my walking billboard! He came to all my fashion shows, no matter where they were. He was there to support me.

One night I was asleep and woke up in a cold sweat. I called my father's car, and I called every hotel looking for him. I knew what time he would usually make his rounds, but nobody had seen him. Before I could finish calling around the doorbell rang, and it was the police. They told my mother that she would have to come down to the morgue to identify his body, and I totally lost it.

When my father died, I shut down. I was only twenty-two years old, and I was devastated. I wouldn't talk. I wouldn't eat. I honestly didn't want to go on. A couple of months later I learned that I was pregnant. I think that's what saved me. You know how people say, "When God takes a life, he brings forth a new life?" Well, they were convinced that I was having a boy just like my father. Turns out they were wrong, because I ended up having a girl!

I am definitely an entrepreneur and a businesswoman at heart. I learned a lot being in the backseat of my father's car, watching him conduct his business. I listened to everything, and now when I do deals it's second nature to me. I never thought about doing what my father had done until recently. I'm buying a hotel in Miami Beach. It's so funny, because my husband is into real estate, and I know business and hotel/motel management. When we talked about doing it, I cried because it was like coming full circle. Who knew that I would grow up and own a hotel like my father? Of all the things I'm trying to do, I just believe this will be the thing that matters most to me, because it honors him. I know it will be successful.

My father enjoyed his life. He didn't miss a beat even when he lost his ability to walk. Once he made his money, he lived. He helped other people, and that made him happy. He achieved not only for himself, but he brought his family along with him. His brothers and sisters worked for him, and they did very well for themselves with his help. He wasn't selfish, and he didn't stop there. He helped people on the streets, he helped his business associates, he helped some of my mother's family, and he helped his friends. Anyone who wanted to make something of themselves, he was willing to help.

What I loved most about my dad was his love for me. The warmth and love that I got from him made me feel so safe. He was that one who made everything okay in my life, and I miss him to this day.

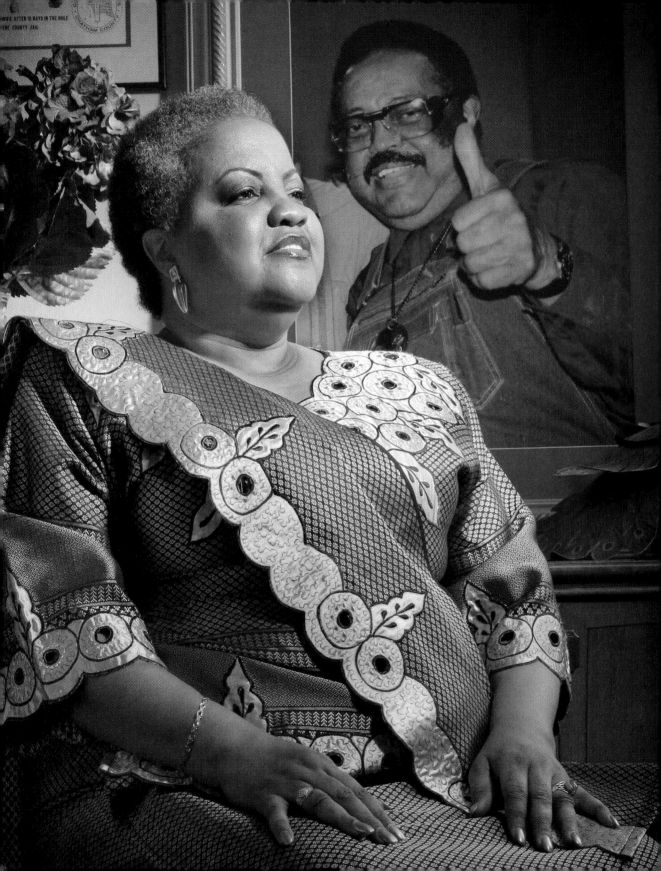

Elizabeth Omilami is the director of Hosea Williams Feed the Hungry and Homeless in Atlanta, Georgia. She is also a noted actress and playwright who has had roles in the feature films *Ray*, *Glory Road*, and *Madea's Family Reunion*. Her father, civil rights activist Hosea Williams, died in 2000.

The General's Daughter

He was just driven, my father. This was a man who you never saw relax. He had an engine inside of him because of how he came up. Both of his parents were blind, he was born dirt poor in the South, ran away from home at thirteen, and then went to the Army. He was always concerned with being somebody. He was determined that he was going to provide for his family, that he was going to have things. My father became the first African-American to be hired as a research chemist in the United States, and he worked with the Department of Agriculture. He was a workaholic, so it was always, "Elizabeth, what are you doing with your life? What are your goals, your objectives?" He was just always driven, and he instilled in me to be the same way.

I was born in Atlanta, Georgia, but we lived in Savannah until 1965. My father loved his family more than anything, and every Sunday we would go to get ice cream after church. We would sit down together as a family to dinner in the early years, before the cataclysm hit— which was the civil rights movement. One Sunday we did go out for ice cream but ended up at the wrong ice cream parlor. And what I heard was "We don't serve niggers here." That day was the day that changed our whole worldview. Daddy started crying—he would cry at the drop of a hat. And I remember standing there thinking to myself, *Ooh, something really bad*

just happened. And he snatched us all up and left. Next thing I knew he had quit his job as a chemist and we were in the middle of a war. And I became a general's daughter.

Suddenly our living room, instead of being filled with all the niceties of the Martha Stewart life, was filled with groups of men and women having heated meetings, filled with the picture that I have in my mind of the burning cross of the Ku Klux Klan outside our window, filled with night rallies where I would sit on the steps of the podium in the church as my father preached. I remember the freedom songs, marches, and beatings and the danger. Black cars riding by the house. My whole world was turned upside down. So suddenly our life was about making this right. "I don't care, Elizabeth, what you have to do, this is what we're *gonna* do. We're not gonna take this anymore, and we are gonna make sure that we change this world that we live in," became the refrain. That was our only purpose for being. There was never a day when we could just sit around and enjoy life. We never took a family vacation. My whole world became about the civil rights movement and about following my dad and pleasing him. Because, for some reason, the most important thing for me to do was to please him.

Daddy was a fiery preacher. His job with the Southern Christian Leadership Conference (SCLC) was to preach to the working class and get them to march and sit-in and stand up—against a system that they *knew* would destroy them. For many, it was certain death. Daddy would pull himself up by his bootstraps and get whoever would go with him and march head on into hell. He had that kind of fearlessness that can only come from some kind of awareness of God. Some kind of awareness that you believe that what you're doing is right and God is with you—and only what He allows to happen is going to happen. It's the soldier, the warrior. Daddy is of the stock who go into war and grab their bayonet and run at the enemy. And I saw him do that so many times, and I would be like, "Wow. How can he do it?" I was so proud of him at those times. How could I do any less? Some of my other brothers and sisters were like, "I don't think so! Get out there with Daddy and get yourself killed if you want to!" But I didn't care what they said. I would be right there with him.

Because he had seen so many people sell out for money and position and title, my father believed in being "unbought and unbossed." "Sell out" in his mind meant you are afraid to speak the truth to power because you might get blacklisted. You won't speak out against the mayor or the governor or the president because you've got your position and you're afraid you might lose your job. You got hired in these big positions in these companies because of the civil rights movement, but you got up there and you forgot where you came from and you

won't hire your own kind. You won't help somebody else, give them a hand up. That's what "sell out" meant to him. So he was determined to be unbought and unbossed. Because he would say whatever was on his mind, whatever he thought, right or wrong. He would *say* it.

He was an entrepreneur *par excellence*. Although the money that he made, the businesses that he ran, he ran for the sole purpose of funding Hosea Feed the Hungry, a charity that was his heart. He never paid himself well. He lived very modestly in a little house over on what is now Hosea Williams Drive, and he never was flamboyant with spending. He would always take the money from the businesses and use it to fund the nonprofit so that he wouldn't have to take grant money from the government, which he felt somehow came with strings attached. He had all kinds of business enterprises, and his statement to us was that you don't have to work for somebody else. He used to say, "Black people don't own a brick on Peachtree Street!" Because of that, all of us have our own businesses; none of my brothers and sisters works for anybody else. We've had to from time to time, but all of us are self-employed and doing relatively well.

My father would not compromise on education. When he was working as a chemist, he always felt less than some of his peers because he didn't have a master's degree or a PhD. My sister Barbara got her PhD, and my sister Yolanda became a lawyer. So I was supposed to go all the way. But I didn't get my master's or my doctorate—and I think he was disappointed in that. He saw in some ways the fact that I wanted to be an actress as a negative because it was such an unsure career, but he never spoke against it. He always supported me.

When he died and I formally took over Feed the Hungry, I didn't think I'd ever act again. I said to the Lord, "You just take it and if that's something you want me to do, then you do that." Sometimes the Lord just blesses us for our willingness. I was willing to give it up and walk away from it. And so the jobs that I've gotten haven't been because I've been pursuing acting—they've been blessings. So it's been, "They don't want you to audition, just come do this part." Tyler Perry calling me out of the blue, or something like that. So that's the way I live my life now. I do Feed the Hungry, and the acting jobs come along as blessings. And I depend on the Lord now to bless us with those opportunities so that we can have the income, because Feed the Hungry can't pay us.

I guess the central thing my father taught me is that you have to give your life up for the greater good. That's what makes him a hero, because I know he had hopes and dreams that he put to the side. He believed that nothing that you want is important really. What's important is making the world a better place.

ELIZABETH OMILAMI

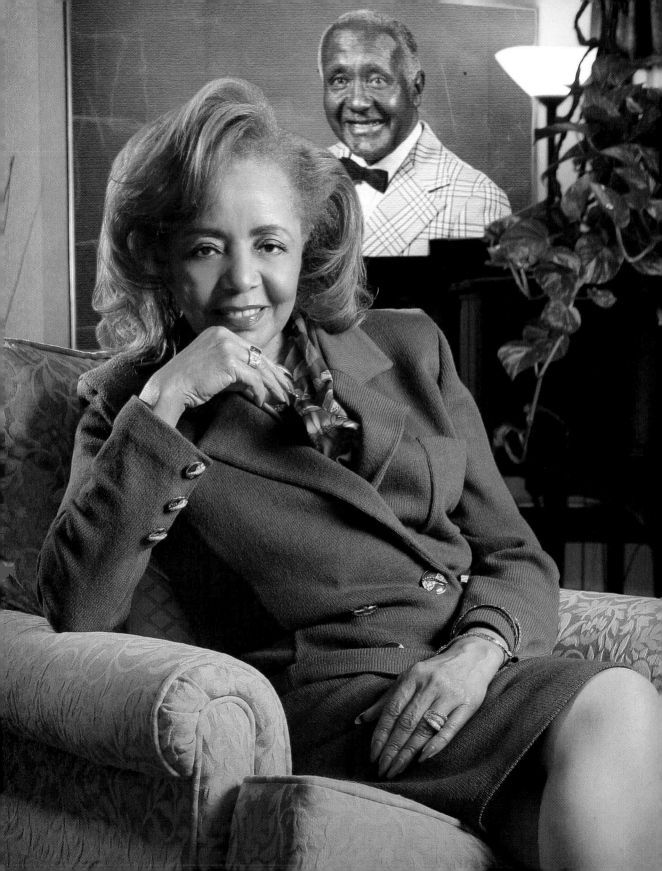

Marvalene Hughes is president of Dillard University in New Orleans, Louisiana, a historically black institution. She successfully led the restoration of the university following the devastation of Hurricane Katrina in 2005. Her father, Judge Hughes, was a farmer and businessman in Eutaw, Alabama, who died in 1991.

Lessons from a Farmer

I was number six out of nine children. Ordinarily, that would mean that one could get lost in that number, but I found a way to have a separate sense of relationship with my father, and I always felt very, very special. When I discovered what interested him, while he was away during the day I learned to attend to things that I knew he couldn't attend to while working, and I would talk with him about them when he came in. I remember talking with him about baseball scores or listening to the political campaigns that were under way so that I could tell him what was happening to people like Richard Nixon or Adlai Stevenson. As a young girl, I found a way to connect with him in a way that he was excited about. I certainly remember having my time, just sitting on his knee and talking.

I grew up in Alabama, and my father was a successful farmer. My father's father managed to own more land than anyone in the entire county, black or white. That was at a time when people in that area, especially black people, were sharecroppers, not landowners. But my grandfather was smart enough to figure it out. So we grew up on a lot of land that was ours. At first it was my grandfather's until my father decided that it was time for him to buy his own land, so he bought his acreage about fifteen or twenty minutes away.

Though he was a farmer, my father actually hauled a lot of the timber off the land, and he had assistants doing the farming. Most of the time he was driving the lumber to where it

belonged and managing the farm, so in reality he was a businessman. I knew that he was out there doing important things and that he was effective with what he was doing. Still, he would come home in the evening, usually with whatever groceries were needed, and spend time with us. The atmosphere was one of love and excitement. All of us ran out to meet him when he drove up in one of his trucks.

My father was a leader in the church, so almost all day on Sunday we were in church, and sometimes we would come back on Sunday evenings for evening service. I was always proud of him when he was serving in the church because that meant he was down front doing things. As a leader, he would give prayers, sing hymns, serve as the head of various church groups, and come home to do more of the same. On Sunday after church we all played baseball—we actually played a lot of sports on Sunday afternoons. I think my father knew that he had to entertain us while my mother was doing whatever she was doing in the kitchen. He was a very kind and honest person, and he did what was necessary to be sure that his children were cared for and that his family was intact.

Sometimes we would all get in one car—how we did this, I don't know—and drive someplace for vacation. My father would take us to visit relatives, or to picnic areas or museums, and particularly to colleges. I think he wanted us to know that after high school this is what you do. It wasn't, "Am I going or not?" It was just a natural sequence.

My father didn't have his college degree, but he did attain some higher education. Both he and my mother greatly valued education. My mother was a teacher, and she had to study evenings and weekends to complete her advanced degrees. He never said to her, "You don't need to get your degrees." It was automatically assumed that she would. In fact, during the summers she went to the university and was a boarding student from Monday through Friday. She would come home on Friday evenings. I also remember that when I finished high school, we left my graduation to go to my mother's master's commencement. I realize that she wouldn't have been able to do what she did without my father's support.

My father was one of the first civil rights activists in town and one of the first black people to vote in our community. He was a prominent leader, so he thought it important to participate in the March on Washington. He didn't come back bitter, however; he came back feeling that he had done something great. There was never any conflict about it as far as I could tell. My father was very careful about the decisions he made and the actions he took, and he was smart enough to maintain relationships with white people that enabled him to carry out

his agenda. He felt that success is finding your independence so that you are not beholden to anyone else's perspectives that are different than your own. He was able to live that.

Dad loved that I worked in education. He believed that education was the avenue for all of us to follow, and we did. It was fitting that my father was the person who first said to me, "You're going to become a college president." At the time I said, "Dad, I don't know. I'm just a vice president." Just a vice president! I remember when I received the offer from Dillard. I decided to get in my car and drive around and think. I was working at California State University at Stanislaus, and I was comfortable there. Dillard would be a totally different environment. As I drove, I found myself reflecting on what my father would think. By the time I'd parked and walked back to my office, I realized that I was probably going to accept Dillard's offer. My father would always say that I should give back. That when you open doors for yourself, think about how you got through and then open doors for other people. This was another opportunity to be of service.

I had been at Dillard for only six or seven weeks when Hurricane Katrina hit. Our entire campus was underwater, and we couldn't go back on campus for an entire year. In fact, it took two to three hundred people from August to January just to finish the cleanup. I then felt that I was there for a purpose, and that purpose was to find a way to restore Dillard. It became very apparent to me that after the 137 years that Dillard had existed, I simply could not allow the university to die as a result of my not giving it my very best. Also, I was not willing to cave in to the political demands to move Dillard elsewhere because I fundamentally believed that it belonged in New Orleans. I had to find the resources necessary to bring Dillard back—and that's a lot of money to find. Bill Cosby and other celebrities graciously agreed to help by performing special benefit shows and raising awareness. And we still depend upon the kind donations that come in via our website, www.dilllard.edu. Somehow we made it work, and I believe my father would have done the same thing.

My father taught me everything I know. He is the person who has given me the most ambition and the highest level of motivation. He gave me the kind of values that sustain me today—values about being honest, ethical, truthful, and doing the very best I can with whatever is placed before me. I've carried them forward in my life, and I'm still carrying them forward. Thanks to my father, they feel very much a part of my foundation. I simply live it every day.

MARVALENE HUGHES

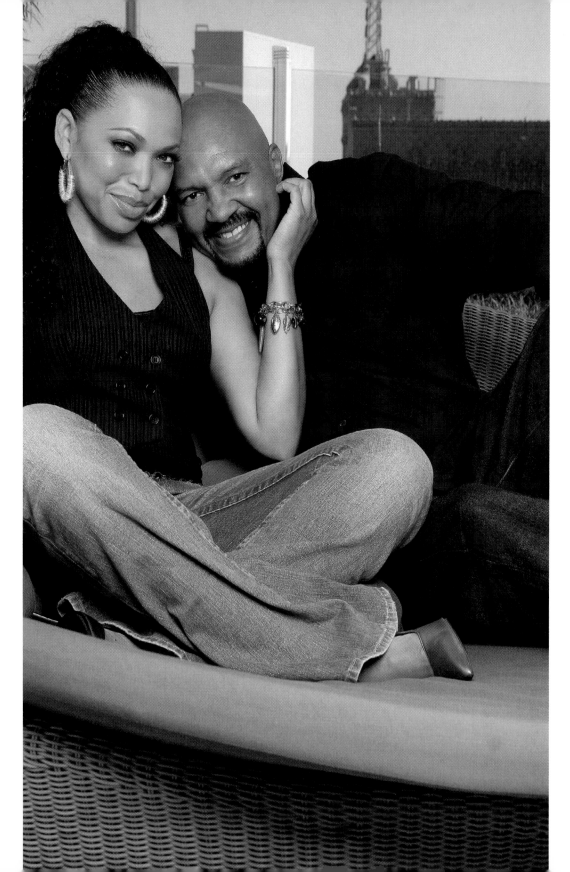

Tisha Campbell-Martin is an actress and singer who is best known for her roles on the popular sitcoms *Martin* (for which she won the 2003 NAACP Image Award for Outstanding Actress in a Comedy Series) and *My Wife and Kids*. Her father, Clifton Campbell, is a retired foster care worker who resides in Los Angeles.

The Resident Dad

I grew up with three brothers, so I was always around boys. In fact, my dad ran group homes for boys who were runaways, homeless, or abused. We actually lived in most of the group homes because my father was not only the counselor but also the live-in parent. When the Division of Youth and Family Services would come to check on things, they were always amazed at the control and the respect and love the kids had for my father. It amazed me, even as a child, how my dad could manage turning most of the boys' lives around.

All the kids in my neighborhood had an affinity toward me because of my dad. He would interact with all of us. Most of the kids we grew up with didn't know their own fathers, so mine became the resident dad. My dad was a clown—a big kid really—and he showed us how to have fun.

People would often see us all together, and because he looked so young they thought he was just some teenager hanging out with us. I remember once, we were all playing stickball in the street, and an elderly woman stopped to look at us with her arms folded. We stopped playing because we didn't want the ball to hit her, so we just looked at her. She said, "Well, I'm just standing here because I want to make sure that young man over there doesn't cheat you." All four of us said at the same time, "Our dad doesn't cheat!" And she said, "That's your

dad?" He married my mother when he was only nineteen, and she had me a day before her seventeenth birthday. They were kids raising kids.

But fatherhood was important to my dad. His father divorced my grandmother when he was five. Then she remarried a man named Campbell, who died when my dad was about twelve. But his stepfather was really hands-on with him, and my dad loved his stepfather so much. So being a father, hanging out with his kids, and really being involved with children was very important to him.

To encourage us he always said, "We're Campbells! We can do anything!" or, "Campbells aren't punks!" He instilled a sense of competition in us. My dad's very competitive. I mean, *very* competitive. In his mind, he's got to win because he's got to make sure the Campbells are on top. I'm the same way because he instilled a tremendous sense of drive in all of us. I'm competitive with myself, which helps me to perform well when it comes to work. And I think it has caused me to push harder to succeed.

We couldn't really take a lot of vacations because we didn't have a lot of money growing up. But when I was working, my dad often traveled with me. I booked a segment on *Captain Kangaroo* with Bill Cosby when I was about nine years old, and my dad would often travel with me to Pittsburgh, where we filmed. I always really enjoyed going away with my dad. I felt so protected with him. As a young girl I used to think that he was the strongest man alive.

I believe that my father is most proud of me at this very moment. He has said so often that he's proud of the woman I've become and the mother that I am. On a recent birthday he told me that when I was born the Spirit of God told him I was going to make a mark on the world. He said, "I never told you this before, but you have. You have made a mark as a mother, as a wife, and in your work." It made me feel really special.

My father's favorite saying is "Do the right thing." And he has taken his own advice. At one point, my father made choices that caused problems in our relationship, and we became estranged for a while. But on his own, he pulled himself up and out of the dark place where he dwelled for six years, took responsibility, and is an even better man because of it. Most of the friends who my dad had growing up are gone or in prison. I think the fact that my dad had children saved his life.

I believe he enjoys being a grandfather more than being a dad. The grandkids call him "Big Daddy," and they adore him because he has a lot of energy and loves to interact with them. He has a way of making children feel like human beings. You know, a lot of times

adults order children around, but my father really makes kids feel like they count. He finds their strengths and exposes them.

If you asked him about his life philosophy, he'd probably say it's "pay attention to your children." He has always tried to live for his children. Sometimes he may not have known how, but he does try. I'm proud of my dad's perseverance. No matter what life has dealt him—whatever mistakes, choices, wins, or losses—my dad has persevered.

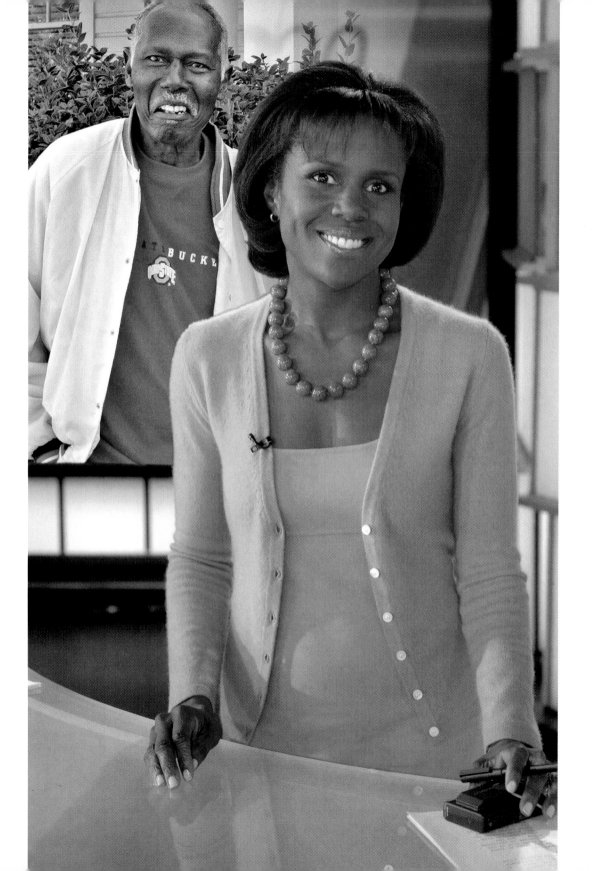

Deborah Roberts is a national correspondent with *ABC News*, who joined the highly acclaimed ABC newsmagazine *20/20* in 1995. Prior to that, she was a correspondent with *Dateline* on NBC. Her father, Ben Roberts, was a retired carpet installer who died in 2006.

The Complete Picture

My father was always on the go because he started this little business of his own. He was a subcontractor who installed carpet. Working out of our house, he drove a van, and he had two or three relatives he employed to help him with installations. I often say to people that if he had been educated and had more business savvy, he would have had a nice little company. But instead, he was one of those absent-minded business guys who always had little slips of paper around the house with people's names on them—people he was supposed to contact—and he was losing something half the time. But he made enough of a living to take care of nine children.

I didn't have a lot of one-on-one time with my father growing up in such a large family, which was kind of a heartbreak for me. You know, my father was the primary breadwinner. My mother had a couple of jobs over the years, and after a certain amount of time she became a homemaker. So I didn't even have much one-on-one time with my mother, let alone my father, who was working most of the time. My father would come in late at night, sometimes even late enough that we were on our way to bed or asleep when he got there. My relationship with my father really began when I was in college, and from then on we got to know each other a little bit better.

As a child, I don't think I much appreciated my father's work ethic, because I felt he was not present enough. But as I grew older what I subconsciously took with me was that tenacity,

drive, and ambition are so important. I mean, my father didn't even have a high school education. His mother died when he was four years old, and he had to quit school to help support his family when he was a child. So given that he had such limited education and resources, for him to be able to build a small business—even if it wasn't completely organized—and to earn enough money to take care of his family spoke to the fact that he had a certain amount of drive and ambition. I didn't realize that I was taking all of that in, but I certainly did. Hard work has been my motto and my mantra throughout my life too. For me, it's all about drive and seeking and wanting and going for it. And I clearly learned those lessons from my father.

My father always had a bright, sunny outlook and a great deal of faith. I covered the first Persian Gulf War, Operation Desert Shield, in 1990, and I had called my parents to find out what they thought about the opportunity when I was making the decision to go. I have to say that I was petrified. I was a young reporter at *NBC News*, and this was one of the first major assignments I had been given. My mother was upset. She was concerned that I would be in the danger zone. But my father said to me, "I think you're going to be just fine. We're going to pray for you and pray about the whole situation, and you're just going to be fine." I think it really forced him to think about me as his child and what I meant to him, but also to think about me as somebody who was striving in a career that was very much unlike anything he had experienced. I believe he considered the fact that I was embarking on something that clearly could take me on all kinds of roads. He couldn't say it, but I think he was really proud of me at that moment.

I don't think my father could have imagined the kind of success I've achieved. He used to watch my broadcasts with pride, and he'd tell me that he saw them. He would watch my husband, Al Roker, on *Today* too. I think he watched mainly to let me know that he was keeping up with what we were doing. Before he died, he said to me, "I've seen a lot of things, but you clearly have seen a lot more than I've seen, and you've been a lot more places than I've been. And I think that's great. I'm so proud of that. But I want you to always remember that you've got to put God first in your life." It really struck an emotional chord with me, because my father didn't usually talk like that. It wasn't his usual style to say, "Here's a little pearl of wisdom that I really want to make sure you carry with you." But I guess because he knew that I lead a very hectic and fast-paced life, he wanted me to remember the Southern values that he had instilled in me.

During my father's generation, fatherhood was earning a living, making sure your family was taken care of, and being there as a figure. I don't think they saw it as participating in the child-rearing experience with the mother. But I believe my father saw it differently later in life. My father took great pride in seeing my husband share in parenting with me. I only saw the stern side of my father growing up. He would say things like, "Hey, what are you doing?" "Cut that out!" "Sit down!" "Stop bothering your mother!" "Stop bothering your sister!"—you know, that sort of thing. But as a grandfather, he joked around with my children all the time.

I have two children growing up in New York City, and they know how to hail a cab and order Japanese food with the best of them! But to have seen them go back and connect with their Southern roots and soak up some of the values that I learned as a child would really, really excite me. My father taught them many of the things that he was raised to care about—commitment, dignity, selflessness, and serving God. I always wanted my children to know their grandfather, and it was nice to see them connecting. Particularly because they were able to connect with him in ways that I never did.

Toward the end of his life, I felt very close to my father, and it was very important for me to try to build upon the relationship that we had. I'm grateful that I had the opportunity. I can say that I have seen the complete picture of my father—the man he had been and the man he eventually became.

DEBORAH ROBERTS

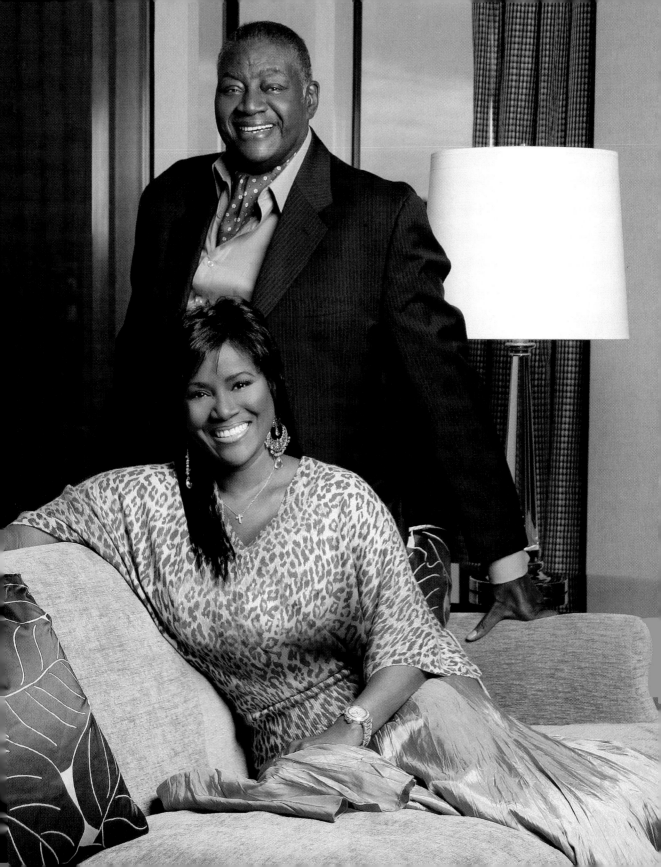

Juanita Bynum is an international evangelist, *New York Times* bestselling author, and recording artist. She is founder and president of Juanita Bynum Ministries in Waycross, Georgia, and her Christian conferences often draw crowds of fifty thousand to one hundred thousand people. Her father, Thomas Bynum, is a retired Oriental carpet salesman and appraiser who resides in Chicago.

Somebody Great

We were a family of four girls and one boy, living on the West Side of Chicago. I remember going downtown to my father's job on Michigan Avenue once when I was about four or five years old. He was an Oriental rug salesman, and he worked in a big open store with a lot of expensive rugs everywhere. I was walking around looking at the merchandise and asking questions like, "How much is this rug?" and, "Why is this rug more expensive than that one?" His boss pointed at me and said, "This one right here is going to be somebody great," and my father said, "Absolutely." Daddy used to always tell me that. He said, "You are going to be somebody great one day."

My sister and I ran track when we were girls. When my father would come home from work, he'd pull up in the front yard, and he would just look at one of us. Then, suddenly, he would strike out and start running. He'd yell out, "You better not let me beat you to the corner!" Even up until about seven or eight years ago, he still liked to race. We were in New York City at that time, and we went out to Junior's to eat. When we left the restaurant, he looked over at me and took off down the street. I took off too, even in my high heels! It was a natural reaction because we were just so used to doing that all of our lives. Everybody was like, "Oh, my God, you can run like that in heels?" I couldn't let him beat me!

We were pretty much the stable family on our block, because my parents were ministers and we were Christians, so people relied on my parents a lot. When things would happen in different families, they would call our house, or the kids would run down the street and say, "Dad Bynum, my parents are fighting." My daddy would go down the street and make peace. He would counsel couples and encourage them to stay together. He was always bringing stray people home—either fellow church members who got evicted or people on the street who needed a bath and something to eat. He would say, "You can live with us. Y'all move over!" Then all of us would be in one bedroom. We grew up with that mentality, and after a while we all started bringing stray people home from our school who were having a hard time. My dad would say that if you always keep somebody less fortunate than yourself in your eyesight, you'll appreciate whatever state you're in.

We used to say to my father that he had another family somewhere. He would go and get groceries, and next thing you know, he'd go out the back door with boxes of food. We'd tease him and say, "Who are you taking that food to? You got another woman or something?" But my father would be all up in the projects. At Christmastime he had a ritual. He would go get candy canes, sugar cane, oranges, apples, and all kinds of nuts. He would make us sit in the kitchen and put the nuts and fruit in plastic bags and put twisters on them. Then he would make us go with him to the projects, and we would give bags of food out to people. I used to tease my father and say, "We're poor ourselves! We can't be giving stuff away like we're rich!" We were just raised that way. I think every last one of my brothers and sisters is like that to this day.

My father's dad died when he was in his teens, and he became the man of the house. He went to work and took care of his brothers and sisters, and I think that once he experienced the responsibility of being a caretaker, he wanted us to know that things don't always come easy. Once when we were teenagers, my father came home for lunch and we were all laying around the house. He put us all in the car and dropped us off in the middle of Chicago. Then he gave us all five dollars and told us, "Don't come back until you have a job, and I mean don't come back!" Two of my sisters had to spend the night with our aunts. My aunts called him to say that they didn't have jobs, and he said, "Well, they can't come back." When he thought we were getting spoiled and out of control, he tried to teach us responsibility.

My father was a shrewd businessman, and he mastered his craft. He could walk into any hotel or house and look down and tell you where a particular rug came from, whether it was

an antique, the type of fibers used to make it, its current value, whether it was made any-more—anything you wanted to know! I'm driven in the same way. I do so much public speaking, and I've made it my business to know how sound systems operate. When I'm ministering and start directing the sound guys from the stage, people in the audience are amazed because the sound quality will improve with just a suggestion or two. I've made it my business to know my craft. My dad worked for a company, but he was so brilliant that they wouldn't make business decisions without him. I watched him stick with something, and I think that's what this culture is missing. We've got a lot of doing one thing one day and something else next week. My father stuck with his craft for over forty years, and that was very impressive to me. Even in ministering, when I'm writing books and when I'm working on my records, it's like I can't quit. I know that came from my dad.

I think had I just had a mother, I wouldn't be as much of a risk-taker. In order to do what I do you have to be adventurous. I'm standing out here in a world where I was told fifty times over not to have events in large auditoriums. Women in ministry are often advised to have their conferences in hotel ballrooms that seat no more than three or four thousand people. It was my dad who said to me when we were at the Congress Hotel in Chicago, "You can't have your conference here next year." The space had become too small—and my dad realized this before I did. I was concerned that people would think I was some kind of renegade or some-body who was trying to prove a point, and I really wasn't. Everything just started taking off for me, and I couldn't help but grow, and my daddy kept encouraging me. He became like the favorite pastor out there who I wanted to be a big brother to me and say, "Come on, Sis, you can do it." I couldn't find that in anyone else, yet I found it at the time in my dad. He would say, "You're gonna do this," and he would constantly ask, "How's the conference coming?" or, "What do you want me to pray about?" I'd say, "Dad, we need $50,000, and I need you to pray right now." And God would do it! My dad just became my anchor until I got to the point where I am now. He still advises me to this day.

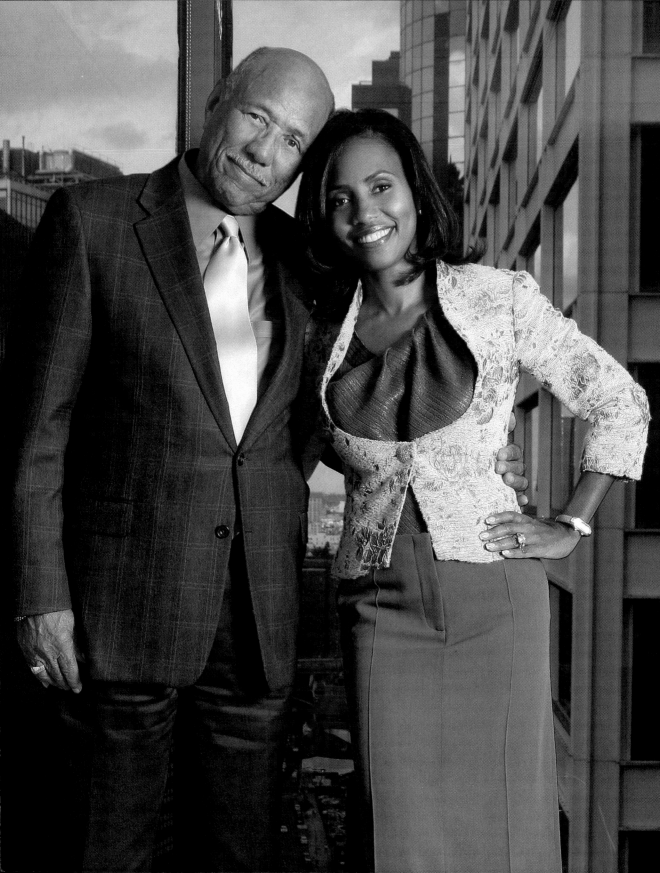

Suzanne Shank is founding partner, president, and CEO of Siebert Brandford Shank & Co., a municipal finance firm with offices in major cities across the country. SBSCO is ranked as the number one minority firm in the nation, with $51 billion in managed issues. Her father, Roger Shank, is a retired transportation executive who resides in Savannah, Georgia.

A Selfless Spirit

My father was one of seven siblings, and he was the only boy. One might think that would make him extremely spoiled—being waited on hand and foot—but it was quite the opposite. From what I know of his childhood, it was he who always had to work and not take advantage of certain opportunities. He did not finish college. He had two years, then had to quit to help support his family. He had an offer to try out for a professional base-ball team, which was his passion, but he couldn't do that because he didn't have the funds to make the trip.

Nonetheless, my father rose, over thirty-two years, to become the director of transportation for the Savannah Chatham County Transit Authority, working his way up from being a bus driver. Being in the Deep South, of course, he faced a tremendous amount of racism and significant roadblocks in order to achieve this. Becoming the director of transportation was not something that many wanted for an African-American.

One of the things I most admired about my father was that he had every job at the transit authority that you could have as he worked his way up. He supervised people in a way that was very cooperative and nonthreatening because he respected what each person was doing, having done the job himself. He is just the nicest person most people have ever come across—probably to a fault. No matter what obstacles he's facing, he always has an extremely

pleasant disposition and outlook on life. As he was trying to penetrate and work hard and do better, there was a feeling that no African-American should go beyond a certain level—no matter what. Yet he didn't handle it with anger. Even when he drove the buses and dealt with day-to-day racism, he was very talkative and outgoing in dealing with people because it was his favorite part of the job.

I rarely saw him angry. If anything, he was hurt. That was so amazing, because I can remember my mom being angry about everything! I was born in '61, and my parents were very involved in the civil rights movement. He would say, "All I can do is the best job I can do, and if people don't appreciate it, that's their problem." He always thought he had to work as hard as he could, and he never wanted accolades. All he wanted was a paycheck. He'd bring it home, deposit it with my mother, and go on from there!

When he got the promotion to director of transportation, he served in that capacity for a few years until there was this move to oust him by the powers-that-be at the time. By then I was an adult, and I tried to advise him. "You know, Daddy, you don't have to take this. We can get an attorney." He'd say, "No I just don't want to do that. I've had a good career." But in reality he faced a lot of injustice, and he eventually had to step down.

I learned a lot from watching my father work his way up in life. Young people today are very quick to fly off the handle and try to figure out a way to excel without moving their way up through the ranks. He started out as a bus driver, and he also drove limousines around for some of the rich people in Savannah. My birth certificate lists my father's occupation as "Negro laborer." That has always struck me, because growing up I only saw him in professional jobs. It has helped me in being very patient as I have worked my way up in the business world. I think patience has done very well for me. I never planned to be an entrepreneur, an owner of a firm, or a president and CEO. It was really others and my partners who said, "Oh, you've got to do this job because you can do it." I just always kept my head down and worked really hard, which my father often told me was the best thing to do, and I was eventually recognized for my hard work. More importantly, my leadership is enhanced by a good deal of solid experience, which makes me much more effective in my role.

One of my father's favorite things to tell me was to use common sense. "Book smarts are not enough," he would say. "If it doesn't seem right, it probably isn't." I am in an industry, investment banking, that has suffered a lot of corporate scandal—Michael Milken, formerly with Drexel Burnham Lambert, with junk bonds, and many municipal officials who've been

bribed as well as firms that have gone down in a cloud of smoke owing to various scandals. For me, it's not all about the fast dollar, because if something doesn't feel right, it probably isn't. When we started our firm in 1996, I knew the details of how we secured every single deal, and it was hard work. Some of our competitors seemed to get big deals so easily. I often wondered how it was that they found success like that, but none of those firms are around today. The steady course and ethics are really the most important aspects of our business.

My father has always been very focused on his faith, and he would never take a dime from anyone. Even down to giving people back change in stores if they had given him too much. It's those little things that you observe when you grow up that contribute to the big picture in terms of the ethics in our society now.

My father has had to overcome many hardships. His father died when he was a young adult, and his mother not too long thereafter, so he did not have a lot of support in life. He had to do it on his own, and he had to put his life on hold because of family circumstances. Because of that, he wanted to be as supportive as he could of me. I know he's endured many things, not for himself, but to provide a better life for my mother and me. He is the least selfish person I know because he gives of his heart, and he has never complained about his sacrifices.

I don't think I would be as successful without my dad because when you know that someone's going to love you and support you no matter what, you can stick with your convictions and try new things. Then if it doesn't work, big deal! I think it makes you a little more adventurous and independent knowing that you have a support system like that. He has made me a stronger person.

SUZANNE SHANK

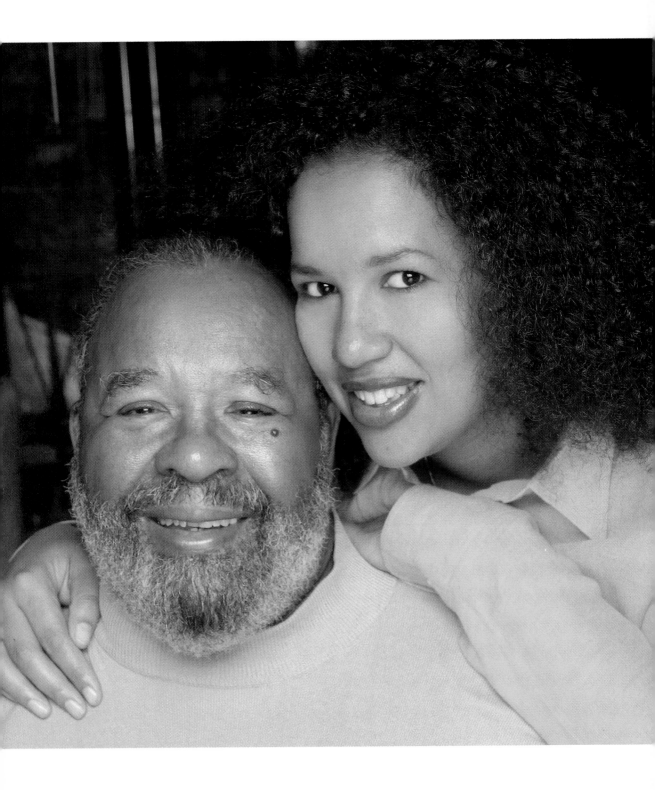

Elinor Tatum is publisher and editor-in-chief of the *New York Amsterdam News*, a historic African-American newspaper. Her father, Wilburt Tatum, the former publisher, is retired and resides in New York City.

The Newsman

When I was five or six years old, my father was working in city government, and he brought me to work with him one day. We were in one of those old boardrooms and there were all these men sitting around a big oak table. I tugged on my dad's suit jacket, and he kind of leaned over and said, "What is it, honey?" and I said, "What if they do this?" I couldn't tell you what "this" was at the time, but I remember that he said, "Excuse me, gentlemen, my daughter's got something to say." I think at that point he showed me that what I had to say was important.

My father was born in North Carolina, the son of a sharecropper and one of thirteen children. His father actually published a small, black farming newspaper in the late 1930s and early 1940s. It came out whenever there were enough ads. My father says he was the managing editor when he was nine years old. The only copy we have of the paper is the issue that has a photo of my father and his twin brother coming back from picking tobacco.

He always loved journalism, and he loved to speak publicly as well. His high school newspaper was an award-winning paper. One of the things they won was a trip to New York City, where they got to guest-edit the Columbia University newspaper. A photograph from that trip was published in one of the black magazines back then. It was a picture of my father and some of his classmates from Hillside High in Durham, North Carolina, sitting around the editor's desk at Columbia University.

My father went to Lincoln University in Lincoln, Pennsylvania, and I believe he went on an oratory scholarship. He couldn't complete his education there because he ran out of money. He then joined the Marine Corps and became the first black drill instructor in an integrated Marine Corps. He served in Korea for a few years and then was stationed in Japan, where he learned to speak Japanese fluently. Then he returned to the United States and finished up at Lincoln.

He moved to New York City looking for a job as a journalist. He wanted to be a writer or reporter or copy guy or anything at one of the major newspapers, but no one would hire him. Frustrated, my father left New York City and went to Sweden with very little money in his pocket. Years before he had met a man named Gunnar Myrdal who wrote *An American Dilemma: The Negro Problem and Modern Democracy.* Gunnar Myrdal was a Swedish man who told my father that if he was ever in Sweden to look him up. So my father showed up there, called Gunnar Myrdal, and Gunnar Myrdal was in the United States! Another friend in Sweden set him up with a little bit of money, a little bit of food, and some telephone numbers. One of the numbers was for a man named Arthur Lundkvist, who became one of the people on the Nobel Prize committee for literature. He became my father's mentor. My father then began to write for many of the newspapers in Scandinavia. He had a column called "Being Black in White America." Eventually he came back to the United States, met my mother, and got married.

I could always write, but I could never spell. I have dyslexia, and my spelling was absolutely atrocious. Still, I could always tell stories. I took part in my first essay contest when I was in seventh grade, but I didn't know how to type. I left my contest essay next to my dad's typewriter the evening before and picked it up in the morning after my dad had typed it. The next day my dad gave me the newspaper. I opened it up and there was a guest editorial. It was my essay! I got so mad at him because the essay contest was anonymous and I didn't want any of my classmates or teachers to know it was mine. I went to a predominantly white private school, and my dad said, "It doesn't matter. Nobody at *your* school is going to read this paper!"

He loves his people, and he loved running the *Amsterdam News.* Because he had worked in city government and even campaigned for former New York City mayor Ed Koch, I asked my father why he didn't run for mayor. He said, "Because I have more power where I am." That told me you didn't have to be in political office to be able to make a difference in the communities that mattered to you.

I knew I'd go into the newspaper business at some point in time. I just didn't know it was going to happen exactly when it did and that I would progress as quickly as I did. I started at the very, very bottom—getting coffee and sending faxes. Then I started writing and editing and moving my way up the ranks over a period of six years. I had just finished my coursework for graduate school and my father and I were at a New York Association of Black Journalists awards ceremony. The *Amsterdam News* bought two tables that night, and I really had no idea why because we never did things like that. One of the women at my table said, "Ellie, did you read the *Amsterdam News* ad in the journal?" I said, "No, maybe I'll take a look at it." I opened it up, and there was this really nice letter, and I closed it and said, "Oh, that was nice." She said, "Read the salutation." It was signed by me as publisher and editor-in-chief, effective that evening. That's how I found out I was promoted. It was truly a surprise to me, because I was so young and I had just finished graduate school. My father was able to pass the torch in front of everybody, and I think that was one of his proudest moments.

Why is my father a hero? I can't think of why my father is *not* a hero. He has a great spirit and a love of life. He has tremendous perseverance, and he's been an inspiration to me and to so many other people—both in the United States and abroad. He has garnered so much respect. Even though he was busy, I always knew he cared.

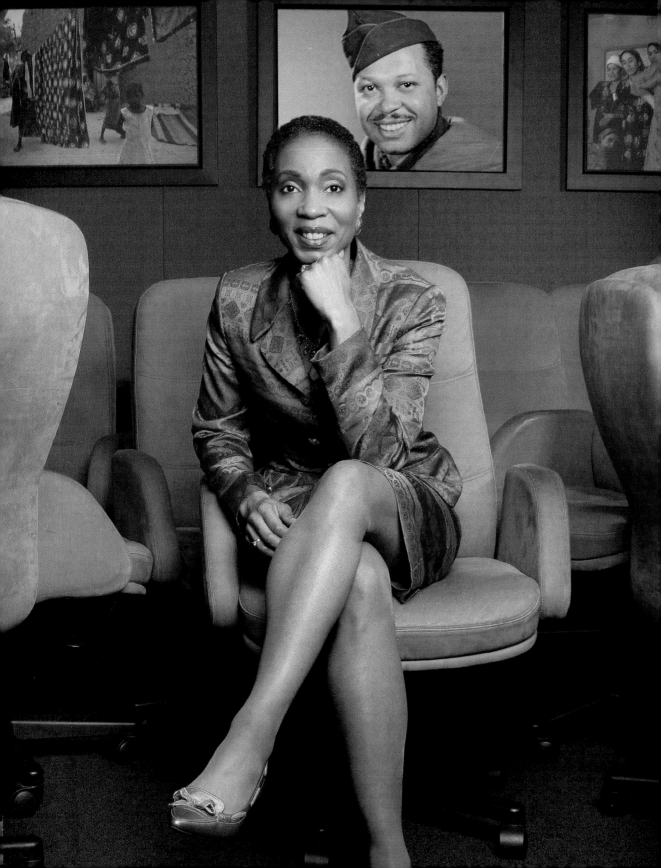

Helene Gayle is president and CEO of CARE, an international humanitarian organization with programs in more than sixty countries, based in Atlanta, Georgia. She is the first African-American and the first woman to serve in this role in CARE's sixty-year history. Prior to assuming this position, she was director of the HIV, TB and Reproductive Health Program at the Bill & Melinda Gates Foundation. Her father, Jacob A. Gayle Sr., was a businessman in Buffalo, New York, who died in 1981.

Always in My Corner

My father was from a small town in Alabama, a rural farming community. He left there when he was in his early teens and came up to Buffalo, New York, to finish his high school education, but he ended up getting married and living his life there. He was part of that migration that was happening for so many blacks from the South. Buffalo, at that time, attracted a lot of people because of its steel mills and grain industry.

My father came to own a small barber and beauty supply store in the heart of Buffalo's African-American community. At that time there weren't a lot of stores that carried beauty supplies made for African-American hair, so he was a real resource. He ran his business as a way of providing a service to the black community. He was always willing to extend credit, even to people who were shaky and not always a good credit bet. He was incredibly generous, and even some of his employees criticized him for being too willing to give people a chance, to take risks on people. He was such a soft-hearted guy and somebody who didn't like to turn people down if they needed something.

The store was a place where all of us grew up. He spent a lot of time working, so being at the store was one of the ways my four siblings and I spent time with him. It was also one of

the ways that we learned about the community and about interacting with a wide range of people. The store was a magnet for all types, from some of the seedy characters in the community to your upright community pillars. We not only learned basic business principles but also honesty and integrity. He'd leave us alone with a room full of money trusting us to count it for the deposits. I think those are the type of experiences that teach you accountability early on.

Generally, my father was a very kind individual who was extremely committed to being a good father and making a living to give his children a better life than he had. My father never got a college degree, but he was a lifelong learner. He took courses to keep up with current business practices, and he wanted to make sure that all of us—two boys and three girls—had educational opportunities. After finishing undergrad at Barnard, I obtained an MD from the University of Pennsylvania, and later an MPH from Johns Hopkins. All of us have a graduate degree today.

Usually after Sunday services at church he would take us around to visit the sick or the elderly. He was very caring and respectful, particularly of elders, so we would often go visit some of the church members who were in their eighties and nineties. His life philosophy was to be good to others and do what you can to serve others. I can remember us talking about the Golden Rule. He wanted us to focus on being kind to people and to think about how our actions and our behavior affected others. He felt that who we were as individuals was more important than who we were in terms of our accomplishments. He wanted us to focus on our character and make sure we didn't lose sight of the type of person we wanted to be, regardless of how much success came our way.

My father was a World War II veteran, and I think that probably gave him a real interest in seeing the rest of the world. My father never had the opportunity, but he always wanted to get to Haiti because of Toussaint L'Ouverture having been responsible for leading the revolution that led to the first independent black state in the world. He just thought it incredible to think of a nation that was run by black people. He understood that Haiti had its problems and trials, but because of what it symbolized for him, he always wanted to get there. Also, he and my mother were always interested in all of those African liberation struggles that were going on at the time. I think for him to see me now as the CEO of a major international organization—having taken what I did in medicine and public health to an even broader arena—I think he'd be incredibly proud.

When I was in high school and first started winning academic awards, my father said, "You should aim high and become a doctor or a lawyer. Make sure that you use your talent." He always made it clear that I had gifts and capability. He instilled confidence in me—that sense of knowing that someone was there for me unconditionally. This was incredibly important for me, because I knew that whether I succeeded or failed, I was still loved. And I think that gives you the confidence to take risks.

When I think of someone who is just an incredibly good person without an ulterior motive, I think of my father. From the kindness my father would show people in his store to the visitations we would do after church on Sunday, he had that sense of profound connectedness to other human beings and the real desire to be a friend. That's something that I hope I embody.

As a father, he is my best example of unconditional love. I always knew that he absolutely loved me and supported me and was in my corner for no other reason than that I was his daughter.

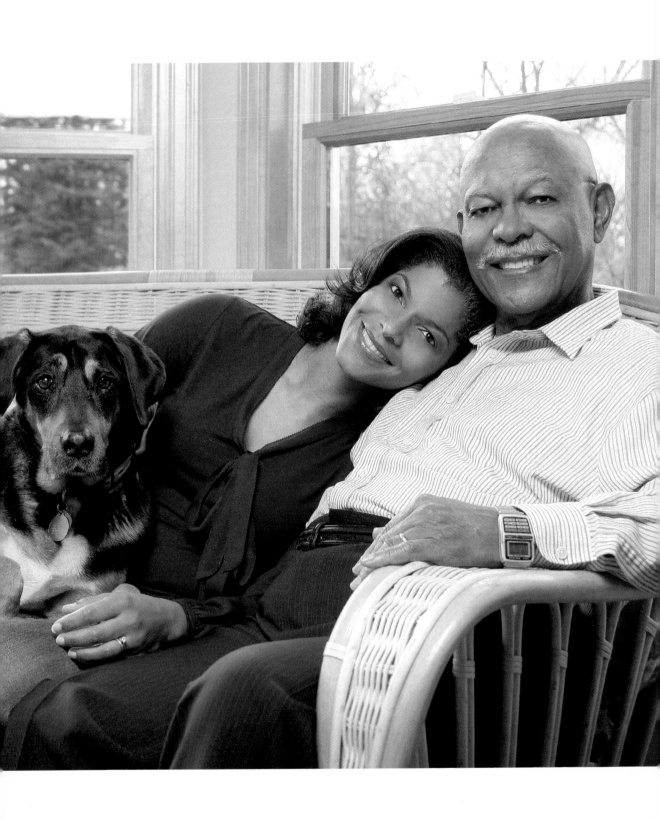

Kim Nelson is president of the Snacks Unlimited Division at General Mills in Minneapolis, Minnesota. Her division earns $1.1 billion in net sales for General Mills and produces some of America's favorite snack brands, including Nature Valley granola bars, Pop Secret popcorn, and Chex Mix. Her father, Alphonso Jones, is a retired math teacher who resides in Altadena, California.

Servant Leadership

I have a very special father. He was a navigator in the Air Force, and after his military career he retired and had a long career teaching. At one point he taught at the Catholic school I attended, Our Lady of Good Counsel. He was my math teacher. It was really fun to have him as a teacher because everybody loved Mr. Jones and he was my dad—I could even call him Daddy in class! He always wanted to do fun things. He would come home and say, "Who wants to go to McDonald's!?" or, "Who wants to go to a movie!?" I remember going everywhere with him. I was his little shadow.

I've learned so many lessons from my dad. Personal discipline is one thing. My dad has never been late to a thing in his life. He's always early. My dad's got a phenomenal work ethic. You get it done and you get it done right. He's also incredibly optimistic and has a basic belief in the good in the world and in people. You would never hear my dad tear people down. It's just not his nature to do that.

My dad grew up in the middle of the Depression. He was the eldest of six kids, so responsibility was important. He had a loving home, but both his mother and father worked several jobs, so he had to help raise his siblings. My dad and his twin brother got scholarships to the

University of Michigan, running track. Even with the scholarships and extra jobs, he couldn't make ends meet. He dropped out, joined the military, and finished putting my uncle through college. He was an incredible man.

When President Truman integrated the military, the Air Force was the place it happened first. The Air Force had an officer training corps that had begun to accept black officers. My dad had wanted to fly his whole life, so he joined the Air Force to take part in the officer training. He was sophisticated, smart, handsome, and so accomplished. I remember him as this larger-than-life, dashing figure in his green flight suit.

When I think of my father, something that he said to me once really sticks out in my mind. He said, "Kim, I raised you to be a citizen of the world." My father, because he was in the military, traveled the world, and he was very comfortable in any culture. He lived in Thailand, so he speaks Thai. He went to Vietnam, and we lived in the Philippines. I grew up in Hawaii. He's so ahead of his time for being this poor black boy who grew up in Washington, D.C. I think he wanted me to be comfortable and at ease in anyone's company. That feeling of curiosity and acceptance and inclusiveness is a gift that he gave me.

He used to also say, "I don't care if you're a garbageman, I want you to be the best garbageman there is." He never cared for my accomplishments. He was always proud of me, but it was never contingent. His way of seeing me has so little to do with what I do because he's not impressed by my title. I'm not saying that he isn't proud of me; of course he is extremely proud. But the things that impress my father are "What are you doing to help somebody?" He's never said that to me directly, but that's where the light leaps into his eyes. If I tell him about a project that I'm working on at church or in the community, that's when he lights up.

I never felt pressure to succeed for him. For him, I feel pressure to be a good person, to do what God has planned for me, and to fulfill my destiny as a servant. That's what I got from my father. Because of him, I know who I am and why I'm here and that I am in a service role. I feel like I've got that voice—it's his voice—that's asking me the hard questions like, "I don't care what you got last year, how much did you give away?" That's what he would be concerned with. I find that you've got to know what matters, because if you don't, you're wasting so much opportunity.

I'm privileged to be able to run a consumer division at General Mills, which gives me the opportunity to organize community service events with our employees and support nonprofit organizations like Habitat for Humanity and the YMCA. Even more broadly on the

business side, I run the Snacks Division. I have to ask myself: What kind of snacks are we going to put in the marketplace? Are we going to put a bunch of junk out there? Or are we going to create a vision for leading America in producing healthier snack foods? We've got limited time here on earth, and I don't want to spend my time in corporate America selling harmful products like cigarettes. I want to use this time and my position to do what I can to leave the world better than I found it.

Fatherhood is so critical. It affects how children will view themselves in the world, especially female children. I have a really good husband who's a great dad, and the reason I found him is because I had a great dad. My dad did the dishes, he did the laundry, he cooked—he did all those tasks well before it was fashionable or acceptable in our society. He was a true partner to my mom and did anything that needed to be done. Mom didn't even have to ask him because he was proactive about it.

I think fatherhood is just about being that safe, strong figure who decodes the world and gives you a sense of your own possibilities within it. A lot of my confidence comes from my father. His love was so unconditional, it was sort of like a God love, you know? One of my favorite quotes is "Imagine what you could do if you knew you could not fail." That's what a father's unconditional love gives his children, because then they're safe from failure. In fact, they have a refuge to go to when failure inevitably occurs.

At every big crossroad in my life, no matter what my age, I pick up the phone to call Dad, even now. My dad's focus has always been less on telling us what to do and more on understanding our hopes and helping us to achieve them. He never forced an agenda, because his agenda was to help you. For me, my father's values and his fundamental way of being in the world is what I've always aspired to. I still aspire to his standards and his ideals. He's still up on the pedestal for me.

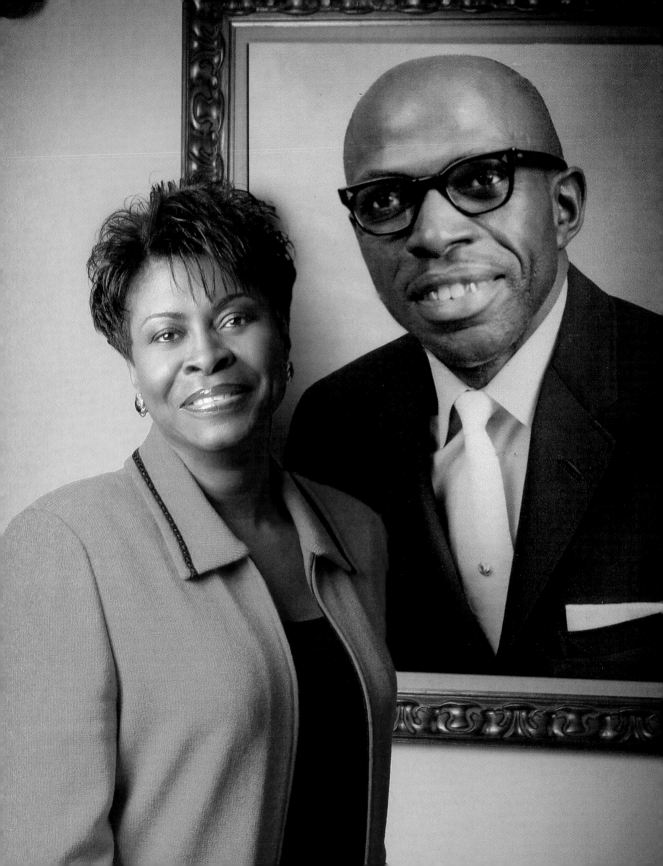

Mae Douglas is chief people officer at Cox Communications, Inc., in Atlanta, Georgia—the fourth-largest cable provider in the United States. Her father, Alton Douglas, is a retired sharecropper-machinist who resides in Greensboro, North Carolina.

A Man of His Word

For the first five years of my life, my family sharecropped on another man's farm. My fondest memories of my dad are of him working on the farm. My dad loves to work with his hands. Life was simple, and the farm was our way of living—we grew everything we ate, and everything was centered around the family.

My dad was born in 1930 so he grew up in the World War II era. Taking care of family was important. Daddy is a person of quiet strength, not a man of many words. I just *knew* everything that he did was about making sure that I got what I needed. He only finished high school, but he had such a strong work ethic. It was about doing what you say you're going to do, keeping your commitments, and working hard. I think watching him be steady really affected me.

I tried to think of a time that my dad didn't keep his word, and I could not think of one! Not one! Maybe that's why I'm still single. I don't think I could deal with a husband if he wasn't a man of his word. That's what I've always been used to in terms of the significant man in my life.

You used to hear people say that women marry men who are a lot like their fathers. I think about that because I don't want a man who doesn't respect me. A man who can't keep his commitments, can't keep his word, or doesn't want to. For me, part of it is biblical. The Bible is very clear on what the role of the husband should be. I think I've been very influenced by my dad, because he's just always been there. That's how I expect my future husband to be for me.

In the era that my parents grew up in, when you got married it was for life. It was commitment, and you just stayed together. There was no option, and faith was so important. God has to work in that relationship. It hasn't always been pretty for my parents the fifty-plus years they've been married, but they've stayed together.

One of the things that I am so pleased about is that I grew up in a family that has a strong spiritual heritage. One of my dad's favorite sayings is "Serve with gladness of heart wherever God has you." My dad is a big servant. He might not have had much, but he was always willing to give to other people. He believed that how you treat others is what you get back, and he very much lives his life like that.

My dad was the handyman for one gentleman for about twenty-five years. This man had been a chief executive officer for a company when Daddy started working for him. He would mow the grass and do little things around the house. Years later the gentleman's wife died, and he was alone. Eventually he moved out of his house into a retirement community. Daddy helped him sell the house, get all the stuff moved out, and get moved into his new apartment. Daddy even took him to his doctor appointments. Eventually the gentleman died, and his family asked Daddy to go to the reading of the will. When he arrived, he learned that the gentleman had left him a new Cadillac and some cash. Daddy was visibly shaken, because he had no idea. He wasn't working for that family to get anything, it was about helping another person. The man's son even told Daddy, "You have no idea how much of a friend my father considered you, Mr. Douglas." That, to me, was just such a telling moment. Here was someone my father served for over twenty-five years, and he got rewarded because of the things he stood and lived for—his actions and his behaviors.

For my father, life is about giving. It's about being a friend. Being a friend to get a friend. His very best friend is someone he has been friends with almost longer than I've been living. My dad is in such great shape, but his best friend has a lot of back problems and some other health problems. I'd watch my dad go to his house two to three times a week and sit with him just to visit. After a couple of his surgeries, Dad's friend couldn't mow his lawn. He has the most beautiful yard you have ever seen. He really took pride in his yard, so Daddy would go mow his lawn. That's just an example of his idea of commitment. I don't care if it's to your wife, to your children, to your employer, or to your friend . . . he just does what he says he's gonna do.

You oftentimes hear people say, "I don't know how they did it," and truly, I *don't* know

how my parents did it! I don't know that I could live off of the money that they made during the time that I was growing up. But our needs were always met. I can remember very early them saving money to send me to college. I knew at an early age that I would go to college because Mom and Dad always talked about it. Even though they didn't do it, they knew that it was the thing. So they were just frugal, you know? They would save and pay for things in cash. And when I went to college, the money was there. It was just amazing to me.

Daddy has always been proud of me. I didn't realize that until after I moved to Atlanta and I would go home to North Carolina to visit. When I'd go to church, they'd tell me, "Oh, your dad told me you just got another promotion." Or, "Oh, your dad told me that you just got back from Asia." Or, you know, "Your dad told me that you built this gorgeous house!" He is my greatest spokesperson!

Daddy knew what to do as a father, and I respect him for that. I think of my dad as the true protector of the family. That's how he lived it, that's how he acts, that's who he is.

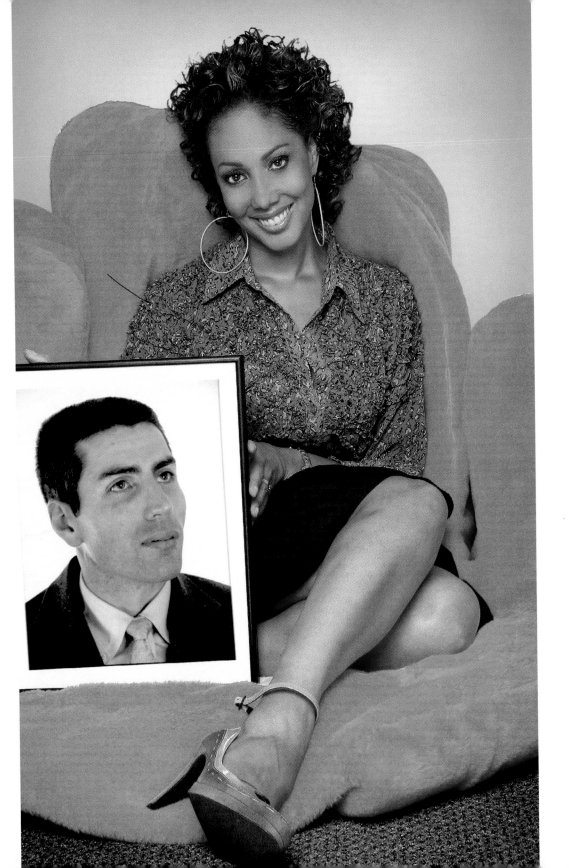

Joan Baker is partner and cofounder of Push Creative Advertising in New York City. She is also an actress, a voice-over artist, and the author of *Secrets of Voice-Over Success*. Her dad, James Palmer Baker, was a retired stevedore who died in 2003.

Dad to the Rescue

I was a daddy's girl. I took dance and acting lessons, and I was on a kids' television show when I was young. He would pick me up from dance classes or acting or from doing a play. We would spend a lot of time talking, and he would tell me about himself and his life adventures, which centered around growing up on a farm in Indiana with nine brothers and sisters. What really struck me more than the adventures in his life was how they sifted through his mind and how he communicated them to me. I felt that it was rare that he opened himself up in a way that was so interesting. I've always loved people and how they think, but I was particularly moved by my father.

My father always treated me as a whole person, not a child, and I always felt respected by him. When he saw how I was manifesting as an individual, he never said, "You're gonna be a nurse," or, "I want you to be a schoolteacher." There was a lot of that going on in my generation—parents who wanted their kids to be this particular thing or that particular thing—but my dad really supported my interests.

Despite his love for education, my father saw that I was an artist, and that's how he dealt with me. I was an average student because school wasn't my thing. My dad wasn't going to force me into getting straight As. His feeling was, if it isn't there, it isn't there. He went out on a limb to support my decision to be an actress, dancer, and humanitarian. I knew he believed in me. Not only did he tell me, but he showed me that I was special when nobody else did.

My father was a longshoreman on the San Francisco docks. He worked on ships loading and unloading cargo from all over the world. It's physically grueling work. He was a stevedore, but he was more like a boss and an overseer of cargo ships. Most bosses sat at a desk and told people what to do. According to everyone he worked with, they used to call him "Spiderman" because he would flip up on the bars and land on the cargo boxes to gain access to some seemingly out-of-reach position. He never told me this. He was just too humble to share certain things. Other people told me later in life that he was physically amazing. Doing all these athletic things every day for forty years when he didn't have to. He was a leader, but in his mind he was also just part of the team getting it done.

When I was growing up, my dad really spoke to me in conversations, so depending on what was going on with me, he addressed it as a singular situation as opposed to a blanket statement. He taught by example, not by specifically saying, "This is something that I expect of you." He really didn't talk to me that way. He would share an experience in his life to communicate his point to me. It was left up to me to make a decision—which I found to be very unusual and trusting.

At one time during my childhood I smoked cigarettes, which was a big, big deal. I considered it death if my mom found out. My mom had told me, "If I ever catch you smoking, I'll make you eat it!" My mom could have been a dramatic actress, and her statement put fear in me. I started crying, and my dad asked me, "What's wrong?" I told him what my mom had said, and through my tears I admitted my secret. I said, "I do smoke, Dad, I do smoke!" He said calmly, "You do?" I said, "Yes!" and then he asked me, "Well, when do you plan on quitting?" So his reactions were just very different. With him, I felt comforted and able to relax and cope. Then I could make good decisions for myself.

Have you ever seen the movie *American Graffiti*? It's a classic from the '70s, and it actually was filmed where I grew up in San Rafael, California. There was a strip called Fourth Street, and all of the high school kids in their cars would go up and down the strip. *American Graffiti* made it famous, but it remained a popular strip long after that. One day I was in the backseat on the driver's side of a friend's car, and I ended up throwing an egg at the car next to me going the opposite direction, and I got a citation. I was really upset, because I knew I would have to go to the police station to meet with the officer—who was nicknamed Officer "Turkey Neck" because he had a really long neck. He was famous among the kids because if you got in trouble and went to Turkey Neck, he was no joke! I was riddled with anxiety, and my

dad noticed it one day and finally asked me, "So . . . how are you?" I started crying and told him what had happened. He couldn't have been more loving and caring. He took me to the police station—we told my mom I was going to the library—and both of us met with Officer Turkey Neck, and it was fine. My dad would come to my rescue like that all the time.

One of my dad's most significant rescues took place in 1991 when I was still struggling to stabilize my career in New York City. I had a seizure when I accidentally overdosed on prednisone, a steroid used to control asthma, which hadn't been working for me. One day I just took a little more. It never occurred to me that this was a drug that could kill me, because I'd taken asthma medication my whole life. The extra dosage caused me to feel really strange, and I thought I was dying. I made it through the night, but when I woke up the next morning I had a seizure. I had fallen out of my bed and ended up on the floor in a contorted, pretzel-like position. It passed without me realizing what it was at the time. Later that day I had another seizure at an audition, and they called an ambulance. A priest gave me last rites, and my parents were called in California and told that I wasn't going to make it.

But my health stabilized, and my father decided to stay with me. I couldn't be alone because I was scared of the possibility of another seizure, so he stayed with me for about a month. Here I was, a black girl living in the big city and pursuing her dreams with her father, the white farm boy from Indiana, by her side. During that time he came with me to auditions, to my talent agency, he even went with me to get manicures and pedicures! I was also a hostess at a restaurant then, and he came to spend time with me there. He really saw how I lived, and he made me feel so grounded. He knew I needed him like I had never needed him before, and I think he was proud that he was able to help me in that way.

That stay was very special, and we both knew it. It was the only time my dad spent with me in New York, and we learned a lot about each other. When he left to go back to the airport, I knew in my heart that it was the last time we'd be together in New York. Dad was diagnosed in 2000 with Alzheimer's disease, and he died in 2003. In 2005, when I published my book, *Secrets of Voice-Over Success*, I arranged for all of the royalties to go to the Alzheimer's Association in his honor.

My dad was physically amazing, mentally and emotionally amazing, and a humanitarian. Our relationship was so close that I understood my father as a human being and not just as a dad. I really feel honored that I knew someone of his inner caliber.

JOAN BAKER

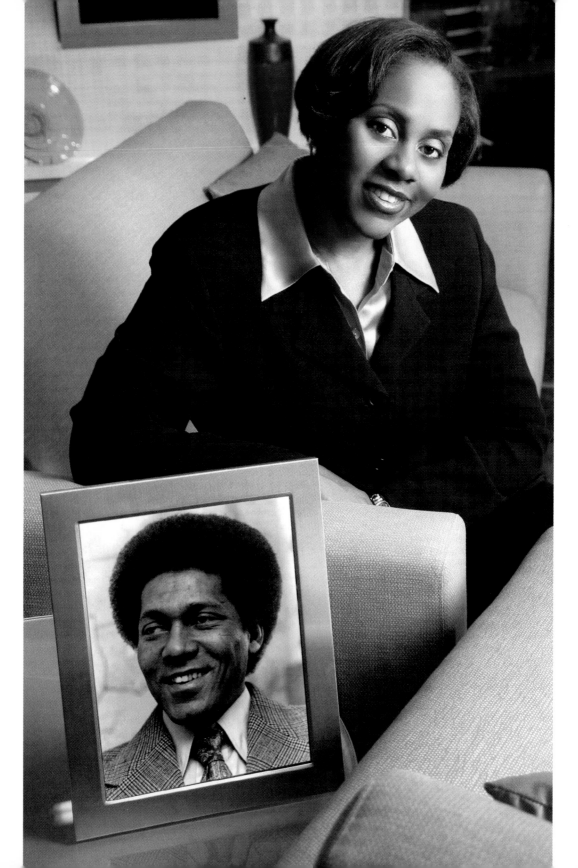

Wonya Lucas is executive vice president and general manager of the Weather Channel in Atlanta, Georgia. Her father, Bill Lucas, was general manager of the Atlanta Braves—the first African-American general manager in baseball. He died in 1979.

A Man of the People

My first memories of my father would have to be at the ballpark. He worked for the Braves most of my life, so my siblings and I would spend a lot of time at the Braves' stadium in Atlanta, Georgia, with my cousins, who happened to be Hank Aaron's children. Hank was playing with the Atlanta Braves, and they lived around the corner from us, so we'd all go to the stadium at the same time. Dad would let us hold the pitching gun, the device that tracked how fast the pitches were. He would teach us how to score the games and the basic fundamentals of the sport, and he would always make it really fun. At the end of the game we'd step on the used cups, popping them with our feet before the stadium was cleaned.

When my father played for the Milwaukee Braves, he would represent the black players, because it was during segregation. At one point he had to stand up to management about the conditions the black players were living under, so the front office always remembered him as a leader. When the Braves moved to Atlanta, they built their stadium in a black neighborhood called Summerhill, and there was a lot of tension between the community and the Braves organization. They chose to bring in my father to work in the front office as a community liaison. Since he had been the person to speak on behalf of the black players and did a really good job of mediating with management, they felt that his personality and skill sets would really lend themselves well to negotiating and being a good community outreach per-

son. Therefore, after his playing days were over, he continued to work for the team, from being the community liaison person to head of ticket sales, to being minor league administrator—the person who was in charge of the Braves' minor league operation.

Atlanta in the 1970s was still very segregated, and I understood that when my father became general manager there was a lot of hatred there. I wouldn't say he was famous, but he was very well known in the city. He was in the news often, and I knew that he had a very special position in the community. One of the things I loved about my father was that he treated everyone with respect regardless of where they were in the organization. I think that was important to him because he grew up in the projects and he sold peanuts as a kid in a minor league park. He remembered there were people who were very kind to him—even many of the players—and so he always extended kindness to everyone. There's a YMCA in Atlanta that is named after him—the Bill Lucas Southside Branch of the Butler Street YMCA. He spent a lot of time there, and he was really instrumental in getting jobs for kids in that neighborhood at the stadium. I look back now and realize that what he could have been and what he was are two very different people. I like that, although he was successful, he was very understated and quite humble.

My father and I liked working in the yard together. He took great pride in his yard, and he would rake the leaves and we'd all jump in the pile. He liked to spend time outside where we would play games such as softball, volleyball, or dodgeball. We would spend a lot of time watching television together. We both just had a love of television—I guess that's why I ended up working in television! I think *The Flip Wilson Show* was one of his favorites because Flip had a great sense of humor and my father had a sense of humor like that. He liked watching shows with black people in them. Back then you just had great pride if you saw someone who looked like you on television. We loved watching *Julia* starring Diahann Carroll or anything with Bill Cosby, but mostly we spent a lot of time talking. My father and I had this kind of relationship that was very unique. It was a father-daughter relationship, but he talked to me like an adult. He would listen to my problems and help me work them out.

I was a very precocious child, and I always wanted to be the best. I was an overachiever, a type A personality. My father always encouraged me to live up to my full potential. He would tell me it was okay to fail as long as you tried. I tried to play the clarinet, and didn't do well at it, but eventually I ended up being first chair. He taught me to stick with it. I tried to be a cheerleader, and I had *no* skills. I didn't make it the first time, but he would always say, keep

going. He'd go into the yard with me and would help turn me around so I could feel what it was like to do a cartwheel, and then I ended up being on a squad when I was in high school. He was the person, without a doubt, who I worked the hardest for. He was such a motivator to me and always encouraged me to do more and let me know that there were no limits. That's what I loved about him. He'd say, "You know what? If you want to do one hundred reports, you do one hundred reports! Go with it!"

I just loved the fact that he loved me. He saw so much potential in me and took the time to really know who I was. I loved that he really did look into your soul and help you figure out how to be the best person that you could be. My father was smart, he cared about all people, he had integrity, he had a great sense of humor, and he was a good family man and friend. He used to say, "If you don't get old, you die young." He was okay with aging, and he lived his life to the fullest. He was only forty-two when he died, but I just think he got it right.

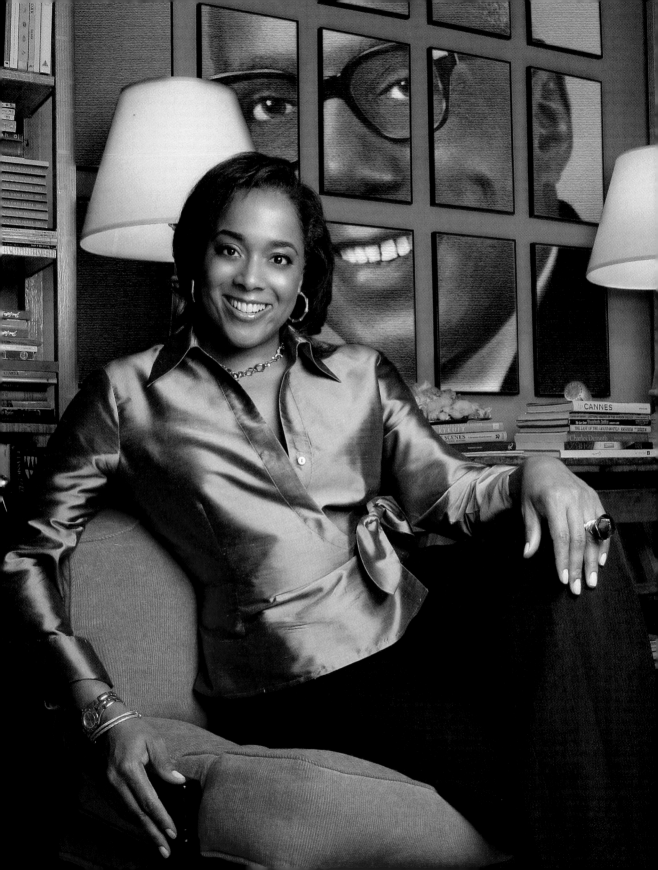

Elaine Griffin is CEO of Elaine Griffin Interior Design in New York City and a contributing editor at *Elle Décor* magazine. In 2006 she became the first African-American to design one of *Southern Accents* magazine's showcase homes, and she is ranked as one of *House Beautiful* magazine's top 100 American designers. She is also a frequent contributor to Oprah Winfrey's *O at Home* magazine. Her father, Dr. David J. Griffin, was a surgeon in Brunswick, Georgia, who died in 1989.

The Gift of Confidence

My father, David J. Griffin, was born in Stewart County, Georgia, in 1914. His twin brother, J. H. Griffin, was the first to go to medical school, and he became an accomplished doctor. My uncle opened a black hospital in the 1930s, the Griffin Hospital, in Bainbridge, Georgia. Eventually my father became a general surgeon as well, with his brother's support. He practiced in my hometown of Brunswick, Georgia, and he was the first black doctor to practice at Brunswick Memorial Hospital in the 1960s, I believe. Before that the hospitals were segregated. So if you were a black person living in Brunswick or its three surrounding counties during the 1950s and '60s, you had to see my dad.

I spent a lot of time at my dad's office because it was a five-minute bike ride from our house. Brunswick is becoming big today, but when I was growing up it was a small town of only thirteen thousand, and everybody knew everybody. My dad's office always had a full waiting room, so you had to bring your lunch when you went because you'd be there all day!

My father was an amazing human being, a remarkable physician, and a kind-hearted soul. I used to work for him during the summers when I was twelve and thirteen, and I would have to keep his files. The details of the records he kept, always using his Dictaphone, were

amazing. He would see the patient in the examination room, and then the patient would come and have a fifteen-minute conversation with him in his office. People don't do that anymore. He would talk with his patients about their health but also their overall lifestyle and well-being. He would take payment in crops if people couldn't pay. I remember every spring a bushel of watermelon would arrive at our house from one such patient. Just because you couldn't pay him did not mean he wouldn't see you. Tons of people couldn't pay, but they knew that if they showed up and they were sick, he would take care of them. He never turned anyone away.

He was never home, so we would have to go see him. My brother and I would go to his office or to the hospital to hang out, and I love the smell of disinfectant to this day. We went to National Medical Association events with Dad because his life was all about work, and we rarely took vacations. That is my work ethic today. So what if you're tired—get it done! The word no does not exist for me, and it did not exist for him. Whenever I have a dilemma, I think, *Who do I have to call next to make this happen?* My dad invented that for me.

I had an affluent childhood because my father was economically blessed, being the only black doctor around. The greatest gift that he gave me was confidence. But at the same time my weekend chore was to clean his room. We had a housekeeper every day, but I had to clean his room top to bottom. I did it from the time I was twelve until I went off to college. I remember once I did a totally half-baked job cleaning his room, because I was tired of doing it, and he noticed. He said to me, "Elaine, you didn't do your best. That's not like you." I felt terrible because he was always saying that we should always do our best. He expected it.

I don't understand complacency, and that really is my dad in me. My mother would say, "Let's leave well enough alone," and I would say, "No, let's do more!" My dad was a "let's do more" kind of person, too. I loved that about him. I would think of the most far-fetched projects, and he would help me accomplish them. And he never said, "That's ridiculous." I remember wanting to do a science project with fiddler crabs. Fiddler crabs only come out when the tide is changing. The first tide of the day changes at around six in the morning. You have to be on the beach and ready by 5:59 A.M. in order to catch them. I woke up one morning, and a box of fiddler crabs was there. He was all about the "if it must be done, it must be done." He never said no. Not to say that they were indulgent parents, because they were very, very strict. Still, if you dreamed it and it was doable, he would do everything he could to make your dreams come true.

When I was a senior in high school, in physics class, the instructor was talking about what happens physically after death. She held up a picture and said, "If your death is under suspicious circumstances, the first person you'll see postmortem is this man. He is the county coroner!" I said, "That's my dad!" It was so cool. She'd been holding up the picture for years. She would tell people, "His name is Dr. Griffin," and then she would talk about what a coroner does and this, that, and the other. I was just so proud at that moment.

My father's a man who overcame the odds for a black man born in the South in 1914. He was the first black man in so many of the things that he did. Which is why I took it for granted that anything I felt like doing, as long as I worked hard enough, I could do. Today I'm fearless because my father was fearless, and I'm persistent because my father was persistent. I am relentless because he was relentless. He was a pioneer.

ELAINE GRIFFIN

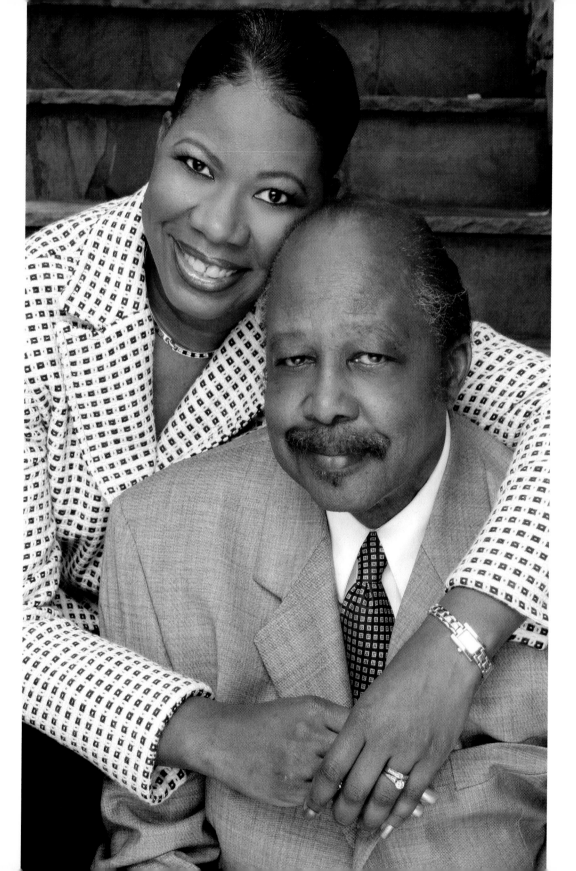

Dara Richardson-Heron is chief medical officer for United Cerebral Palsy of New York City, a nonprofit agency that provides multiple services to more than eighteen thousand children and adults with cerebral palsy and other developmental disabilities. Richardson-Heron holds a B.A. in biology from Barnard College and obtained a doctorate degree in medicine from New York University. Her father, William Richardson, is a retired accountant who resides in Oklahoma City, Oklahoma.

Seeing with His Heart

In addition to my dad's job as assistant supervisor of accounting at Lucent Technologies, he helped manage his father's real estate and gas service business. I must have been six years old when on the weekends he would take my two sisters and me to the gas station. While he was checking to make sure everything was okay, we girls were just so excited to pump gas. The customers would give us tips, and we thought this was a big deal. Then we would go to a real soda shop and have strawberry soda, actually made from real strawberry syrup, and he would take us out to get hot dogs. Those were some of my first memories.

Many of my friends thought of Daddy as a father figure and a role model, but initially they'd be afraid of him. When my sisters and I were dating, guys would come over, and he'd have a one-on-one chat with them. The meeting typically started out with—and I'm quoting some of the guys who've experienced it—"the most painful handshake I've ever felt." Then he would say something like, "I love my daughter. If you know what's good for you, bring her back exactly the same way she left here, or I'll come looking for you." That was kind of the introduction to my father that most of the guys received. After that initial chat, he would develop a strong bond with some of those guys because he didn't have any sons. He had four

daughters. Many of those guys he still has relationships with to this day—long after our boyfriend-girlfriend relationships ended.

My dad was always around and involved in whatever we were doing. With a lot of families, the father was the breadwinner and the mother was running around to the kids' events. It was similar in our family because my dad was the provider and my mom didn't work when we were growing up, but somehow my dad was always there whenever there was any kind of event in our lives. The school play, a birthday party, a piano recital—whenever we were involved in something, work for him was second-place. So many of our friends wished they had the kind of father we had.

There was always a family day at my father's workplace when I was a little girl, and we'd dress up and go there and meet his coworkers. As I got older, he would come home and talk with us about some of the things that he experienced at the office, things he perceived as unfair or racist. At the time, we thought, *Daddy just complains all the time. He can't get along with anybody!* We didn't understand it then, but he was preparing us for life as adults. Daddy was also such a hard worker. He might have been sick on the weekend, but he never missed a day of work.

Certainly my father could have been in a higher position at work if our family wasn't such a priority for him. My dad is a CPA and he has a master's of business administration, so he was going to be on the fast track at his job. They wanted him to move from state to state to state, and he refused those promotions because he wanted to create a stable family environment for his children. He gave up a lot for us. I think when he is recognized for being a such a great father, it confirms in his mind that he did the right thing.

Daddy talked to us about what he described as "the seven important attributes for a successful life." He came up with these seven attributes and put them in writing in 1990 when he wrote a special Valentine's Day card to all of us. The attributes were love and respect for yourself and your family, pride in yourself and your accomplishments, character, determination, patience, intelligence, and love of God. He was such a revolutionary guy!

He made it clear that he had high expectations of us, and he only gave us credit when it was due. If I gave a speech, my father might say, "No, Dara, you didn't execute, you really didn't speak the way I know you can speak. You should have practiced more. On a scale of one to ten, I give you a three, and that's just not gonna cut it!" Sometimes it felt kind of harsh, but by the same token, when we did something well he would reward us. When we were all in high school, I remember my older sisters and I being so excited about Daddy buy-

ing us a brand-new car. He always gave us the best of everything whenever we did well. Actually, he'd sacrifice and drive an old raggedy car so that we could have the new one.

Another thing he told us was "I only accept As and Bs in this house. Don't bring home any Cs." We just didn't do it. We didn't make Cs. It's bizarre looking back on it now, because what if you had a child who did make a C? I asked him that once, and he said, "I just knew that you didn't have to make Cs. If you studied hard, you could always get As and Bs." If he saw that you were having a problem, however, he'd help you. I remember my dad driving my sister forty miles to a tutor who specialized in a subject she was struggling with so that she could improve her grades. Even though his standards were high, he would also get you what you needed to succeed.

I was most proud of my father when he stopped smoking after reading my third-grade homework assignment, "My Most Important Wish." I wrote, "I want my Daddy to stop smoking so that he will be around to see me graduate from High School." I guess I've always wanted to be a doctor, and I've always had medical tendencies. Somehow I knew smoking was bad. I wrote the essay at school, and I brought it home for him to check my homework. My mom said he almost fell to pieces when he read it, and shortly after he just stopped smoking. I was so happy because I realized then that it mattered to my dad what I thought. He quit smoking just because I asked.

The things my father taught me about working harder and being smarter than the next person, not being mediocre, were key. Also, he taught me to understand that racism is a fact of life, but not to wallow in pity about it. These things have been tremendously helpful for me as an adult.

It wasn't until I started working in corporate America that I realized what a tough world it was. Those living room chats with my father when he would say, "Don't let anybody break your spirit," have really been valuable to me. My father thinks that life is difficult and fraught with many challenges, successes, and obstacles and that no matter how smart and how successful you are, you're going to experience failures. There's a quote from Confucius that goes: "Our greatest glory is not in never falling, but in rising every time we fall." He has certainly demonstrated that.

My father definitely sees with his heart. He's not outwardly demonstrative all the time, but he has committed himself totally and completely to his family. He always made us feel like we were the most important people in the world.

DARA RICHARDSON-HERON

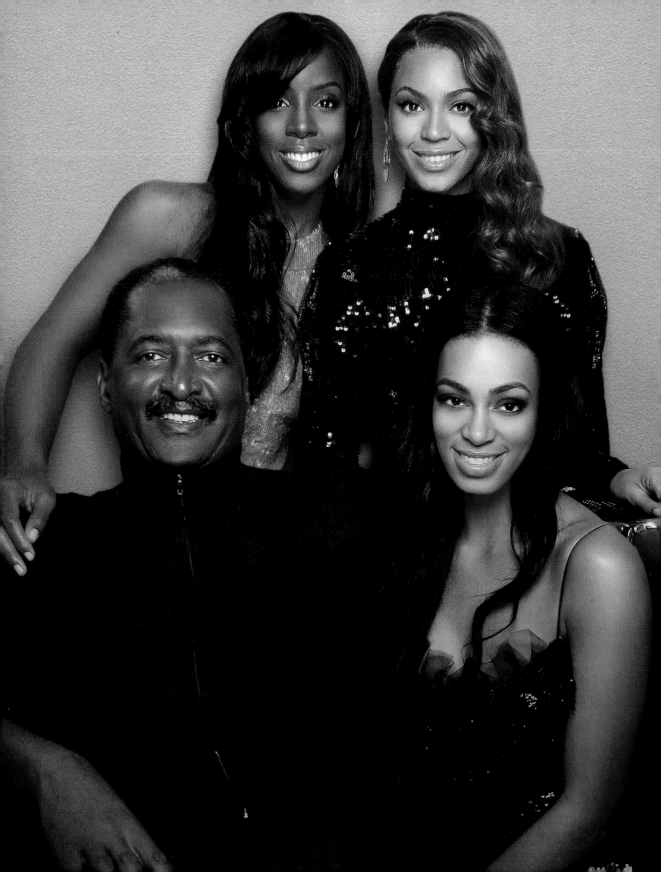

Beyoncé Knowles and Kelly Rowland are members of the multi-platinum R&B group Destiny's Child, which has sold over sixty million albums and singles worldwide. Both have appeared in numerous television and film projects, most notably *The Hughleys*, *Eve*, and *Girlfriends* (Kelly) and *Austin Powers in Goldmember*, *The Pink Panther*, and *Dreamgirls* (Beyoncé). Recording artist and actress Solange Knowles is slated to release a second album and has appeared in the films *Bring It On: All or Nothing* and *The Johnson Family Vacation*. Their father, Mathew Knowles, is an entertainment executive who resides in Houston, Texas.

The Motivator

Kelly Rowland

When my mother and I moved to Houston from Atlanta, I hadn't seen my biological father since I was about four years old. I remember just missing my father. When I would see other kids, and especially little girls, with their fathers, I would think to myself, *I want a daddy.* I loved my mom, but you always want both parents.

Beyoncé and I met through a mutual friend and quickly became best friends. It was just amazing that when I met her family, Mathew instantly became this father figure in my life. It happened so naturally. I started living with them when I was eleven years old, and I remember how good it felt to have a father again. I was so happy and kept thinking to myself, *I have a daddy now!*

The first time I called him "Daddy," I remember running back to my room and crying.

I didn't want to overstep my boundaries, because I loved Beyoncé and Solange so much that I didn't want them to think I was intruding. When he told me it was okay to say it, I cried even more! It felt good to finally call him Daddy, because that was what he was in my heart.

The way my dad encouraged me was with his pep talks. I remember my voice being extremely small, and I was always "singing little." I sang very softly. He would say, "Sing out! You've got this big world to sing to, and it's *your* world!" His pep talks gave me so much confidence. Even now when I'm performing, I still hear his voice in my head.

When we were kids, I remember him asking us, "Do you guys really, really want this?" We'd say, "Yeah, we want it!" He would say, "Okay, then we're gonna work for it." And we did. I remember when we first got started and we recorded Destiny's Child's first hit song, "No, No, No." We didn't want to get up to promote the record on early morning radio shows because it was so early, but we did. The single eventually went platinum, and so many different successes happened after that because we worked hard. I think he was most proud of us when we got our star on the Hollywood Walk of Fame. Just because we all dreamed of something like that, and the fact that it actually happened kind of blew us all away. I will always be thankful to him for instilling a strong work ethic in us at such a young age. A lot of people honestly didn't do what we did. We worked hard because we had somebody in our lives to teach us the importance of working hard, even when we didn't feel like it.

With my dad, mind and heart go together. He believes that once your mind is set with your heart, every door can be opened and anything's possible. That's what he's taught us ever since we were kids. You have to believe it and you have to see it. With my dad, it has to all make sense. If something in the equation does not make sense, he says, "Why would you do that?" He is all about creating balance.

One thing that's so cool about my dad is that he's full of integrity. It's not easy to find a guy like that. He has taught me to be smart with my choices in men. He has encouraged me to believe that love is real and you can definitely have it, but you have to be careful with your heart. If I'm having a conversation with a guy and I don't feel that same kind of warmth like I feel from my father, I think to myself, *Next!* He's just not the one.

I know my sisters and I wouldn't have become successful women without our dad. From balance to happiness to ethics to confidence—there are so many things that he nurtured in us that help us now. He's incredibly smart. The fact that he reads so much about the enter-

tainment industry and has asked so many questions, that taught us to ask questions as well. He would tell us, "If you don't understand something, ask questions. It's the only way you'll get the knowledge."

I remember being a little girl who struggled with confidence and felt like she was missing something. He came into my life and showed me that everything was going to be okay. Every time I think about it I'm moved to tears. He taught me that I could get through anything if I just believed.

Solange Knowles

When I was about five years old, my sisters would be rehearsing and I'd always want to get involved with what they were doing. My dad would say, "Okay, Solange, we're going to think of something special for you to do too." He would always try to incorporate me and make me feel like I had a special job within the group.

One of the things my dad has always encouraged is confidence, not just in our careers but in everything. I remember getting in trouble a lot at school because I was so outspoken. My father would go to the school and ask my teachers why I was being punished for being honest. It was his feeling that as long as I was being respectful, I shouldn't be punished for speaking out. I was always proud when he defended me.

The things that he taught us about having confidence and standing up for what we believe in really help us today. When you're in this industry, it's very, very hard to stand up to people. Especially when you're a young woman and the people you're working with are so seasoned. Without my father's influence, I would have backed down so many times. Show business types will tell you that they've worked with this person and that person allowed them to do this—they think they know what's best for you. I didn't go for a lot of the things people have tried to push me into because of my father. Actually, with me he created a monster, because whenever we disagree I'll say, "Remember when you told me to stand up for what I believe in? Well, I believe that I don't need to do this."

My father was a sales rep for Xerox when I was growing up. He graduated from Fisk University. He was very pro-college, pro-Fisk, but when I explained to him that I didn't want to go to college he understood. My mother established a top hair salon at twenty-five years old without a college education, so there's always been that balance of creative and educational enlightenment in our family. I was able to make a case for what I thought was best for

me, and he respected my decision. Everyone calls me junior him. Watching him work over the years I've learned the way that his business mind thinks, the way he conducts and organizes his company. As a result, I'm very business-oriented when it comes to my career, and I have a strong sense of what needs to be done.

One thing that I respect about my father is that he has never been driven by financial gain. Of course, everyone wants to live comfortably, but my father worked hard to create something great. That was the accomplishment, not the money. Success in our minds comes from the places we've been, the people we've been able to meet, and the things we've been able to do. He's always tried to teach us that we can do these things and work hard and when it's over let the accomplishment be the reward. When my friends come to his house, they're always surprised that he only has two cars. He has definitely passed that on to us, because we all live very modestly. If I were to say that I wanted to buy three cars, he would look at me and say, "What sense does that make?" He has taught us to invest and to be smart with our money versus going out and buying everything just because we can.

He's a proud father. One of the things that he enjoys is being able to sit and watch all of his girls be successful, support one another, and present ourselves well. Not to toot our own horns, but we're good girls. You're not seeing us out there dancing on tables, because he's raised three ladies. I definitely know that that makes him proud. Also, he has helped us to be independent. We don't have to go to men to provide happiness or security. We can combine what we have with a partner and create something good together—and my father has given us that mind-set.

I definitely consider my dad a hero in my life because I know that no matter what I'm going through, and no matter what I need, he will find a way to come through for me. I know that's something a lot of women and girls can't count on with their fathers. If I said today, "Dad, I want to be a lawyer," he would use every resource he has—and find new resources—to make sure that I could do it. Lots of little kids say they want to be recording artists or movie stars, but to actually have someone who sees that and creates a foundation for that to happen? That's a hero.

Beyoncé Knowles

When my dad realized that I really wanted to sing, he went all out to make sure that it happened. He built an area for the group to practice in our backyard, and he made press kits

about the group that he would send to everyone with an ear for music or a knowledge of the music industry. And he did all of this before he was officially our manager.

My dad was one of the top sales executives for Xerox, selling medical equipment for brain scans. He worked really hard, and as a result my family had a good life and we were well cared for. For example, my dad always took us on family vacations every year. It was important to him that we had time together to bond and to experience other cultures. Eventually, my dad quit his job to work with the group full-time. He was making top dollar at Xerox then, so it was a real sacrifice that he left his job to manage us. My dad had no idea we were going to be successful. He just believed.

Because my friends were also a part of Destiny's Child they became a part of my family. They were at my house almost every day of the week, so my dad became like their dad. They loved him just as much as my sister and I did. He taught us all to work hard, to always learn as much as we could, and to try to be the best at what we were doing. His perspective was that success only comes to those who work hard and go after it—to those who are driven. Even today, my father works so incredibly hard. He is always thinking and strategizing about what to do next. And he always has an idea about how to improve. Also, he would often say, "Never doubt yourself," or, "Trust your first instinct," This advice has helped me so much in my life and will stay with me always.

You never realize the sacrifices your parents make for you as a child until years later. Now I am extremely proud of my dad when I think of his faith and his willingness to go out on a limb for me. But what I love most about my father is his ability to love his family so effortlessly, so completely. He has always been there for us and he has worked hard with his family in mind. Basically, my father taught me what it means to be loved by a man and respected by a man. And I have carried that with me my entire life.

KELLY ROWLAND AND SOLANGE AND BEYONCÉ KNOWLES

PLACE A PHOTO OF
YOUR DAD HERE

Daughters of Men recognizes that the father/daughter pairs featured in this book are only a small sampling of the numerous inspirational father/daughter stories that exist within the African-American community. If your father, or a surrogate dad, deserves to be a part of this book, please use the following pages to write a personalized essay about him as a special acknowledgment for his love, support, encouragement, and commitment in your life. Enjoy reminiscing!

INCLUDE YOUR FATHER ESSAY HERE

*All hair, makeup, and grooming by Toni Acey (www.toniacey.com),
with the exception of:*

Yolanda Adams (makeup by D'Andre Michael for MargaretMaldonado.com), page 72.

Rene Syler (makeup by Patrece Williams of PattiCake Cosmetics, Inc., hair by Kim Serratore), page 68.

Juanita Bynum (makeup by Gwynnis Mosby, hair by Natalie Spencer), page 120.

Brandy Norwood (makeup by Eric Ferrell, hair by Kiyah Wright), page 44.

Sheila Johnson (hair by Shirrita Szczesny), page 8.

Solange Knowles (hair by Kimberly Kimble for MargaretMaldonado.com), page 160.

Beyoncé Knowles (makeup by Francesca Tolot of the Cloutier Agency, hair by Kimberly Kimble for MargaretMaldonado.com), page 160.

Cathy Hughes (hair and makeup by Martina Maina), page 24.

Sanaa Lathan (makeup by Motoko Honjo of ArtistsByTimothyPriano.com, hair by Redell Scafe of the Platinum Agency), page 36.

*All photography by Derek Blanks (www.dblanks.com),
with the exception of:*

Deborah Roberts (courtesy of The Disney/ABC Television Group), page 116.

Ben Roberts (courtesy of Ken Krakow), page 116.

Hosea Williams (courtesy of Elizabeth Omilami and the Williams family), page 104.

David Ray McCoy (courtesy of LisaRaye McCoy and the McCoy family), page 100.

Bill Lucas (courtesy of Wonya Lucas and the Lucas family), page 148.

Thomas Sears (courtesy of Leah Ward Sears and the Sears family), page 16.

Major Leon Adams (courtesy of Yolanda Adams and the Adams family), page 72.

William Syler (courtesy of Rene Syler and the Syler family), page 68.

Johnnie Cochran (courtesy of Tiffany Cochran Edwards and the Cochran family), page xviii.

James Baker (courtesy of Joan Baker and the Baker family), page 144.

George Peter Crump (courtesy of Sheila Johnson and the Crump family), page 8.

Harry Wright (courtesy of Deborah Wright and the Wright family), page 32.

William Alfred Woods (courtesy of Cathy Hughes and the Woods family), page 24.

Alton Douglas (courtesy of Mae Douglas and the Douglas family), page 140.

Judge Hughes (courtesy of Marvalene Hughes and the Hughes family), page 108.

David J. Griffin (courtesy of Elaine Griffin and the Griffin family), page 152.

Theodore Evans (courtesy of Chrystal Evans-Bowman and the Evans family), page 64.

Jacob Gayle (courtesy of Helene Gayle and the Gayle family), page 132.